REPRESENTING

PICTORIAL CURRENTS IN
SOUTHERN CALIFORNIA ART

GORDON L. FUGLIE

FRYE ART MUSEUM

SEATTLE

In association with the University of Washington Press
Seattle and London

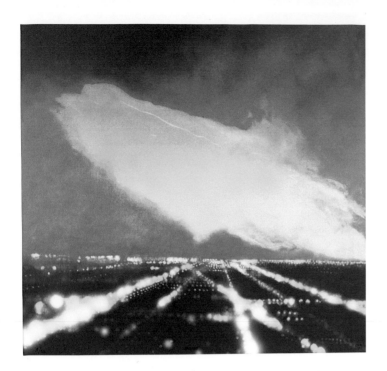

CONTENTS

FOREWORD

Richard V. West
Director, Frye Art Museum

The current "revival" of representation as a viable modus operandi for visual artists provides an instructive lesson in the history of modern art. During the past five decades, the official verdict promulgated in classroom and studio was that "painting is dead"; the very idea of mimetic art was considered, at worst, a ridiculous imposture or, at best, as irrelevant. The majestic triumph of Modernism, which in American art lore was initiated by the Armory Show of 1913, allowed little deviation from the notion that abstract and nonobjective art was the ultimate and highest form of visual expression. Imagery, if it was allowed at all, was accepted only if presented in a manipulated or ironic form, as in Pop Art. All of this was taken for granted by most art students and art lovers, despite the fact that for a number of artists, and a few brave critics and dealers, the continuation of figurative art was never in question. Albeit scorned and fragmented, figurative artists continued to practice and teach where they could, forming a sort of underground resistance movement to the imposed hegemony of Modernism.

In Southern California, two artists stand out for their inspired refusal to give up on representational art: Rico Lebrun *(1900-1964)* and Howard Warshaw *(1927-1977)*. Close friends and colleagues, both artists were outspoken and articulate advocates of figuration in a hostile critical environment. The rigorous aesthetic discipline that Lebrun and Warshaw brought to their public dialogues and their teaching was considered too intellectual, too academic, to be taken seriously by most of their contemporaries. Yet, Lebrun and Warshaw continued to put forth the idea that the Renaissance and Baroque were not mistakes and that a truly modern artist could still continue to learn and build on that heritage. Warshaw, for example, authored a 1960 article in *Nation* magazine, "The Return of Naturalism as the Avant-Garde," surely a brave concept at a time when Abstract Expressionism was the establishment style of choice. Lebrun's critical and polemical writings were equally compelling and have recently been gathered together and republished. In many ways, this presentation of contemporary representational art from Southern California validates Lebrun's and Warshaw's efforts, even though many of the artists included here are too young to have known or studied with them.

I was fortunate to know both Rico Lebrun and Howard Warshaw. As an undergraduate art major, I studied with Howard and participated in dialogues with Rico; after my graduation, Howard remained an inspiring friend and mentor up to his untimely death. This publication and the exhibition it documents are in large part the repayment of a debt of gratitude to Howard and Rico, and I am pleased to dedicate this effort to their memory.

INTRODUCTION

Gordon L. Fuglie

This exhibition owes its existence to three factors. The first factor is historical: in the past twenty-five years, the breakneck pace of one art movement succeeding another—the very hallmark of late Modernism—finally faltered and collapsed. I personally witnessed this "closing phase" while an art student in Southern California during the 1960s and early 1970s. In a period of less than ten years, Abstract Expressionism declined, Pop Art rose, was succeeded by Minimalism, and, hot on its heels, Conceptual Art emerged. Performance art, video art, and Earth Art were also born. Locally, Los Angeles earned a nationwide reputation for midwifing its own novelty—"Light and Space" art. Looking back, what remains of these movements and "isms" seems rather pale, or scarcely exists. Here and there, now and then, some artist may try to reinvigorate them, and for his or her trouble gets labeled with a "neo-" or "post-" qualifier.

In 2000, the American art world is in an ambiguous place called Postmodernity, a term used to denote some vaguely expanding terrain where many art modes are permitted to flourish in hopes that one more new thing might take hold. As for the notion of the avant-garde, only naïfs or the culturally deluded still give it credence. Any artist who seriously identifies herself or himself as such, or a curator who tags the term as a title for one of his or her exhibitions, invites a pie in the face. Can anyone really speak of artistic progress in 2000?

What is truly blooming in the postmodern world, however, is representational drawing, painting, and sculpture. Despite seasons of heavy plantings of successive non-representational trends, representational work has sprouted like never before; no amount of art-crit Roundup has killed it. And, as the hundred-plus works discussed and illustrated in this publication demonstrate, representation ranges widely across traditional to edgy sensibilities. Unlike most other contemporary work, moreover, it doesn't look exhausted.

The second factor: in a thirty-five-year period from the early 1960s through the late 1990s, Greater Los Angeles transformed itself culturally from a regional outpost to an institutional art center that could claim rivalry with New York. In this astonishingly brief period, the following museums came into being: The Los Angeles County Museum of Art; the J. Paul Getty Museum (both Malibu and the fabulous Getty Center in Brentwood); the Norton Simon Museum of Art; the downtown Museum of Contemporary Art; the UCLA Hammer Museum; the Orange County Museum of Art; the Museum of Latin American Art; and numerous smaller museums and public galleries. Even the once-staid Huntington Library and Art Collection in San Marino underwent reinvigoration.

Local university and college art programs also grew. Among leading art schools are the University of California, Los Angeles; the California Institute of the Arts; Art Center College of Design; and the Otis College of Art and Design. University museums and galleries expanded as well: the University Art Museum at California State University, Long Beach; The Frederick R. Weisman Museum of Art at Pepperdine University, Malibu; and the California Museum of Photography, affiliated with the University of California, Riverside.

All these robust institutions now constitute a richly variegated tapestry of visual culture and study—the pre-1965 era seems a mere skein by comparison. In this period, they have given the region greatly enriched public collections at a time when acquisitions were costly and difficult; brought major national and international traveling exhibitions that were previously unavailable to the West Coast; and, perhaps most importantly, originated significant exhibitions that traveled from Los Angeles to other cultural centers. In education, a number of artists, art historians, curators, and administrators were nurtured in Southern California. The development in depth of these cultural resources made it much less tempting for young artists to go to New York or Europe to study. A first-rate education could be had here, and the strengthened local collections and exhibitions offered inspiration to artists. By no means the least of all was the establishment of a network of serious commercial galleries that displayed the work of both the seasoned and emerging artists of Greater Los Angeles. The breadth of commercial spaces also meant that good figurative or representational artists could find galleries willing to show their work.

A third factor: in the early 1990s, Ruth Weisberg, a figurative and narrative painter/printmaker (now Dean of Fine Arts at the University of Southern California), realized a sizeable number of like-minded artists were active in

Greater Los Angeles and, noting that they lacked a critical mass, decided to convene them. At that time, the city's contemporary art institutions (critics, public galleries, and museums) were aware of only a few artists working in figurative or representational modes; a great number of others were unknown. Weisberg thought that bringing together these relatively isolated individuals would give them a sense of their achievements and goals as a body. With fellow painter James Doolin, she compiled a two-page list, and they brought together a large gathering in a downtown studio. All who attended were surprised and delighted to encounter other figurative and representational artists beyond their own circles. After some efforts to have these gatherings (dubbed "the figurative group") turn into a venue for formal discussion of issues facing these artists, factions formed, a few heated quarrels broke out, and after two years the group dissolved. In retrospect, most of the artists who participated in "the figurative group" acknowledge that it served an important purpose in affirming their direction and exposing them to the work of their peers. Indeed, some later formed smaller groups for more specific purposes, such as pooling modeling fees for drawing sessions, discussing art historical or philosophical topics, or even collaborating on projects.

To summarize, in the early 1990s it was—ironically—the undefined character of postmodernism that allowed a number of previously ignored or reviled figurative and representational artists to be looked at with fresh eyes. In addition, recently developed cultural institutions in Southern California became sources of encouragement and support for the artists. Finally, meeting together for two years gave many of these artists their particular sense of identity in the wake of Modernism's dissolution.

In the years since "the figurative group," Weisberg became increasingly certain that an exhibition of the work of its original participants (including some new faces) would be a powerful affirmation of what *Art in America* critic Michael Duncan calls "L.A.'s figurative revival." When she broached the subject with Frye Art Museum director Richard V. West in 1998, his own familiarity with the Southern California art scene and the Frye's mission to show contemporary representational projects brought this publication and the exhibition it documents into being. Owing to my direction of the Laband Art Gallery at Loyola Marymount University (LMU), where I annually present figurative exhibitions of Los Angeles artists as well as write essays on them for *IMAGE Journal*, I was asked to be curator of this exhibition. With the assistance of LMU art history student Sinead Finnerty, a call for submissions was sent out and numerous studio and gallery visits were undertaken (Sinead also conducted a number of taped interviews with artists which were valuable in writing the catalogue). The number of artists and range of approaches that we reviewed was enormous, exceeding all expectations. By the spring of 2000, it became apparent that *Representing L.A.* needed to be encyclopedic in scope. To get some order in the selection process, I found that a number of works clustered in distinct sensibilities. After repeated viewings, I refined and divided these sensibilities into nine themes: The Artist, Portraiture, Identity and Self, The Body, Narrative, City, Landscape, Still Life, and Spirit. Some of the themes represent continuity with earlier traditions in Western art; others seem to be loaded with *Zeitgeist*, whether universal or specific to Southern California. I was particularly drawn to works that reckoned with Los Angeles events and landscapes.

In the end, my approach has been to identify what I found to be important currents in the resurgence of local representational work done over the past ten years and not merely illustrations of the nine themes. I am more interested in what these works do for the viewer's aesthetic pleasure than in what they may mean as part of some "theory of representation." Moreover, I have chosen to be catholic in my selection. I have no problem with works that hew closely to earlier traditions, because I believe the best part of those traditions remains vital. More adventurous or frisky pictorial approaches were just as welcome in my selection, but the omission of certain artists will reveal something of my curatorial parameters. It is my hope that this publication and exhibition will encourage more specific and scholarly projects on Southern California's recent representational revival. Finally, I am grateful to all the artists, galleries, and collectors who helped *Representing L.A.* come into being.

Gordon L. Fuglie
Laband Art Gallery
Loyola Marymount University

THE ARTIST

As early as the late Middle Ages, artists began to appear as subjects in their own works, establishing a socially elevated role for themselves and reflecting a new humanist sense of the individual. Thus, a tradition was established that for the next five hundred years enriched portraiture, becoming a distinct subcategory within the genre. With this legacy informing them, Southern California figurative artists bring a range of vocational identities to their images — of the self and other artists — expressed in neotraditional and nontraditional modes.

Long Beach lithographer Cynthia Osborne poses her artistic identity in the work of her hand and her medium of choice. With a visual double entendre, the artist whimsically titled her lithographic drawing and screenprint *Megalith Envy.* On a more serious level, her work honors the two hundredth anniversary of lithography, the medium that allowed artists to reproduce their drawings (albeit in reverse) just as they were originally executed on planed slabs of Bavarian limestone. In the foreground, Osborne's hand makes a portrait on stone of a Stone Age monument that is backed by mountains, presumably of limestone. The work places the artist/printmaker's vocation within the realms of geology and prehistory.

The working environment of the artist is the subject of works by F. Scott Hess, Yu Ji, and Ruth Weisberg. In *Mud on a Stick*, Hess portrays himself poised to apply pigment with brush onto his canvas, which is turned toward us just enough to make it possible to realize that it is similar to the painting we are viewing —an insight into the production of three-dimensional illusion. In a composition redolent of Western art history, the artist is seated next to a work table upon which are ordered numerous brushes, mediums, and tubes of oil paint. His gaze at the viewer humbly asks us to consider

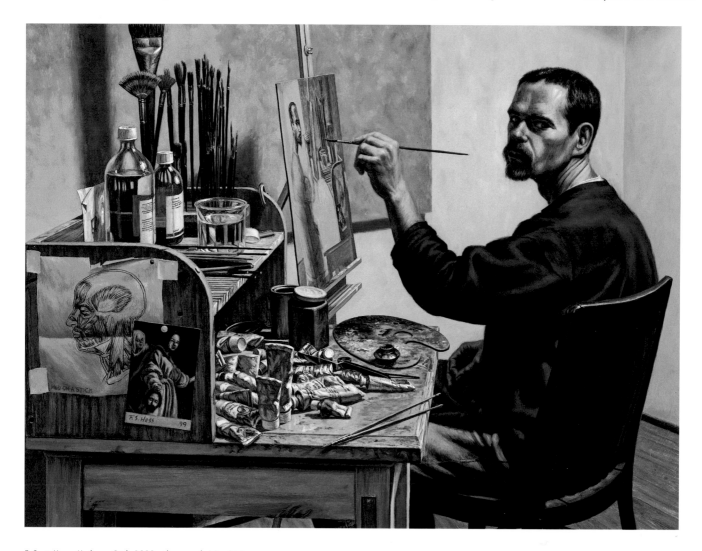

F. Scott Hess, *Mud on a Stick*, 1999, oil on panel, 18 x 24 in.

Facing page: Cynthia Osborne, *Megalith Envy*, 1998, lithograph and screenprint, 20 x 15 in.

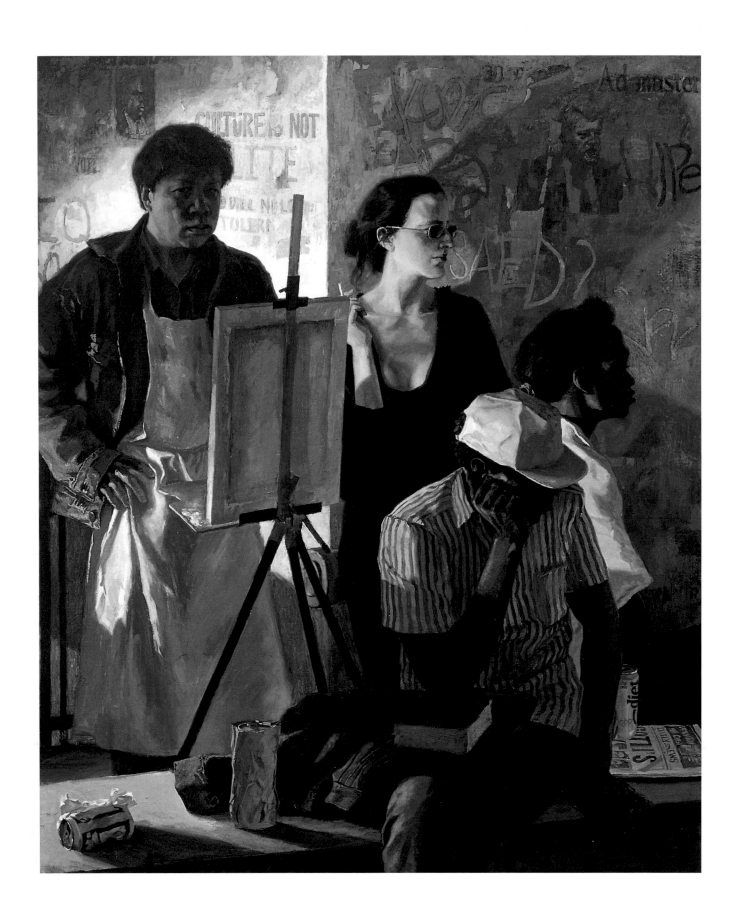

Yu Ji, *Street Corner,* 1994, oil on canvas, 40 x 30 in.

Ruth Weisberg, *Now, Then,* 1991, oil on canvas, 64 x 95-1/2 in.

the painter's craft and calling. In contrast, Yu Ji, who was educated in the academic tradition in the People's Republic of China, places his aproned self and "studio" in the streets of the city. While in New York, Ji became fascinated with the racial and class diversity he saw in Manhattan and carried his sketchbooks into the parks and outdoor cafes to "take in" the complexity of American urban life. A Los Angeles resident since 1999, he finds the cultural diversity of Southern California equally challenging.

In Ruth Weisberg's monochromatic painting *Now, Then,* the studio without the artist's bodily presence is the subject. Her composition pays homage to Swiss sculptor Alberto Giacometti by re-creating his studio in Paris; it is also an empathic linking of her vocation with his in the sense of the isolation of artistic labor.

Although the artist may be absent, other forces are potently present in the studio. Amid the bottles and brushes, what may be a muse (Weisberg's adolescent daughter Alicia) glances furtively about the studio. Above and beyond the high windows, a sculptural frieze of singing winged putti—a plaster cast of Donatello's *Cantoria* in Florence—literally forms a higher level of inspiration drawn from the formidable legacy of Renaissance culture.

In contrast to the *gravitas* of these depictions of artistic identity are the quite different self-portraits by Stephen Douglas and Robert Williams, from Venice and North Hollywood, respectively. Douglas' quirky nine-foot-high painting reveals a scene that takes place in his studio, where, framed against a brilliant red backdrop, the pensive artist is swirled in a black, columnar garment that has compressed

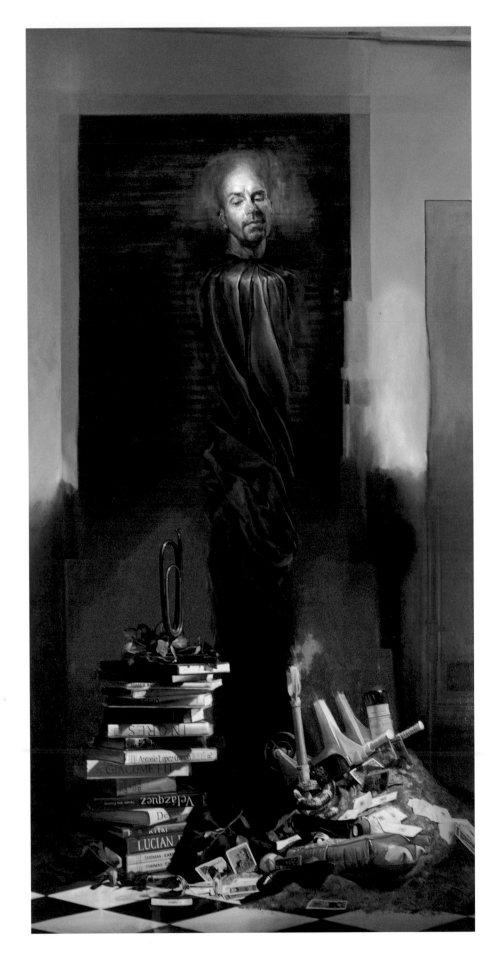

and attenuated his body. At left is a stack of art history monographs about the great artists in Douglas' pantheon. At right, an excavation seems to have taken place and tarot cards are scattered across a pile of earth. The artist completed the painting as a kind of self-registration after the breakup of his marriage. Is the bugle atop the books meant for sounding taps on this part of his life?

Robert (aka Robt. Wms.) Williams, whose business stationery boasts a career that has been "fouling the art world's nest since 1957!" melds an illustrative style with hot rod culture and extreme narrative—he's never met an over-the-top approach he didn't like. In *The Were-Artist,* a variation on the werewolf legend, Williams stages a fantastic scene on a Mojave Desert highway where a wolf is transforming himself into an artist, complete with beret, brushes, palette, and paint tubes (which are gobbled up by the metamorphosing figure). Among a swirl of superimposed 1950s deco-forms and a menacing zigzag demon, *The Were-Artist* goes way, *way* beyond the notion of the romantic artist as demiurge.

Multiple representations of the artist come from the brushes of Enjeong Noh and Jon Swihart. In Noh's *Doppelgänger* (a living person's identical counterpart), two similar figures of the nude artist lie on a bed, one

Robert Williams, *The Were-Artist,* 1992, oil on canvas, 30 x 36 in.

Left: Stephen Douglas, *Untitled,* 1998, oil on linen, 108 x 55 in.

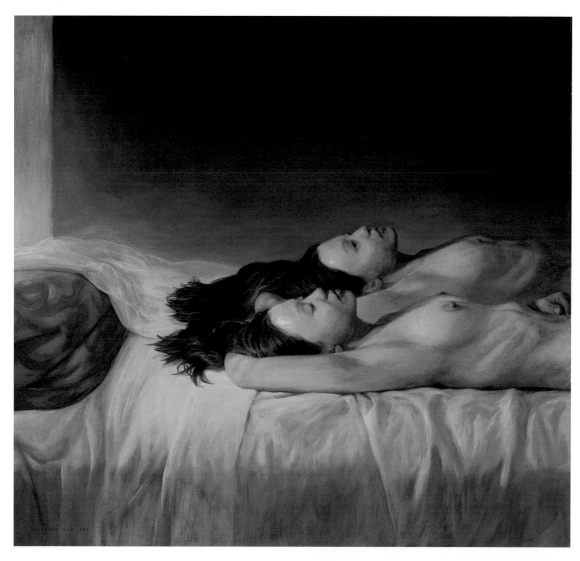

Enjeong Noh, *Doppelgänger,*
1999, oil on canvas, 28 x 30 in.

gazing into the dark void, the other with eyes
shut—perhaps a meditation on conscious
and unconscious inspiration. In *Tenax Vitae*
(Tenacious Life, an ambiguous title), Swihart
has painted a double image of his friend, the
artist John Frame. Seated in an autumnal
rural locale, Frame thoughtfully broods over
his own unconscious form. The work is also a
kind of collaboration: the architectural ele-
ment enclosing *Tenax Vitae* was constructed
by Frame.

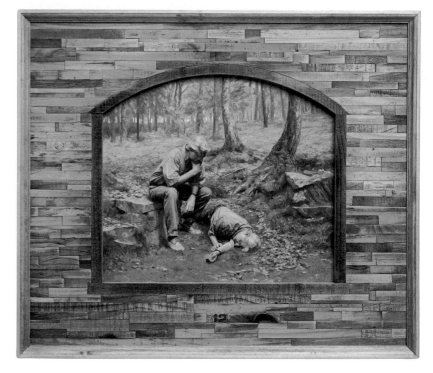

Jon Swihart, *Tenax Vitae,* 1997,
oil on panel, 17 x 21 in.

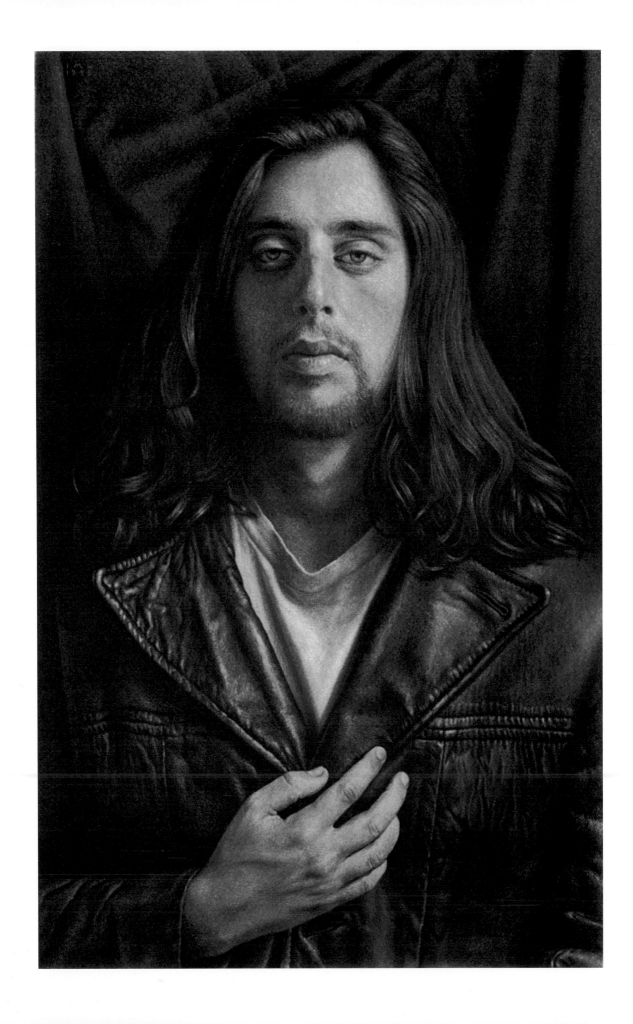

PORTRAITURE

Until the mid-nineteenth century, artists who couldn't capably execute historical, mythological, or biblically themed works could find a niche in the genre of portraiture. There was always a need for a likeness, whether the artist had the insight and skill of a cosmopolitan Parisian master like Jean-Auguste-Dominique Ingres or the passable abilities of a limner ensconced in the rural byways of southern France. Despite the introduction of photographic portraiture by Louis-Jacques Daguerre in 1839, painted portraiture persisted under the patronage of the growing middle classes and, of course, the wealthy, who continued to sit for it as they do today.

By the close of the nineteenth century, painted portraiture increasingly had become suffused with traits it didn't have at the beginning of the century: expressivity, a certain soulfullness in the artist's apprehension of the sitter, and new, unusual subjects, such as Van Gogh's postman and Gauguin's South Sea Islanders. If the mechanical camera could always give an accurate likeness, the artist's pencil and brush would conjure the subject's inner psychology. In the contest for producing the most meaningful representation of the subject, this sensibility gave the drawn and painted portrait the "imaginative edge."

One hundred years later in Postmodern Los Angeles, a wide range of practices in portraiture can be found. There are artists who accept traditional portrait commissions but whose personal work has a distinct contemporary approach in style and content, such as Craig Atteberry, John Nava (see also *Narrative*), Stephen Douglas, and Jon Swihart (see also *The Artist*). Further along the spectrum are a number of other more imaginative approaches including edgy "anti-portraiture" (Salomon Huerta), historicism (J. Michael Walker), and parodic commentary (Margaret Morgan), to name a few.

The affable Peter Zokosky (see also *The Body*) is a painter of a philosophical bent who, in his own words, chooses "to employ sound craftsmanship, an understanding and appreciation of historical precedents, and absolute adherence to personal authenticity." From this sober, sincere declaration, his paintings explore the nexus of life and death, humanity and bestiality. A superficial glance at his small portrait *Habilis* gives the impression of a kind of conventional memorial to a deceased adolescent of indeterminate gender. Closer scrutiny, however, reveals either a simian likeness of a humanoid ancestor or a primate on the cusp of humanity. The vulnerability (or is it an emergent soul?) in *Habilis'* countenance unsettles the viewer, to say the least. Historical precedents also engage Ira Korman, who ten

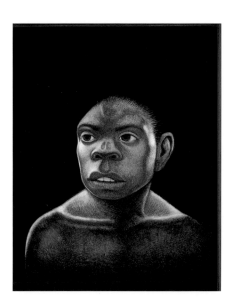

Peter Zokosky, *Habilis,* 1998, oil on panel, 10 x 8 in.

years ago forswore color and painting for the exclusive rigors of monochromatic drawing. The charcoal on paper *Jolyon (After Dürer)* was derived from Korman's encounter with Albrecht Dürer's auspicious midmillennial (1500) self-portrait in Munich's Alte Pinakothek. Korman was struck by both the directness and range of subtleties in the Munich portrait; when he returned to California, he posed his brother-in-law as a hip version of Dürer's "artist-Christ." The divinely inspired vocational dignity that was announced in the original self-portrait is recast in Korman's portrayal as a cool, heavy-lidded countenance of secular gravity.

Facing page: Ira Korman, *Jolyon (after Dürer),* 1995, charcoal on paper, 30 x 19 -1/2 in.

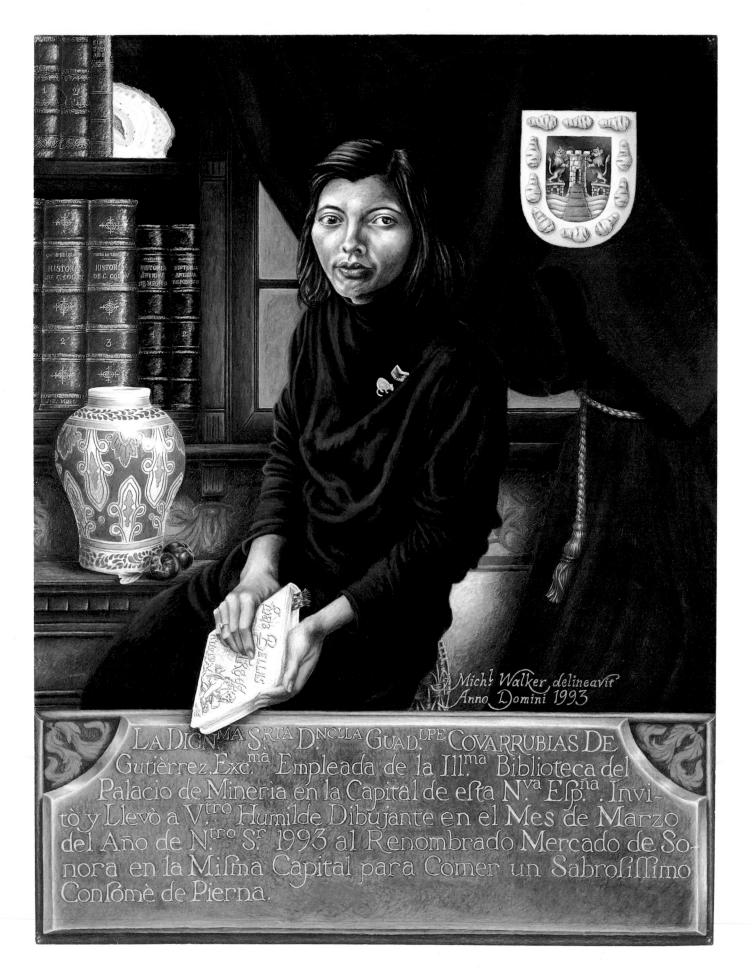

Mich! Walker, delineavit
Anno Domini 1993

La Dign.^ma S^rta D^nclla Guad.^lpe Covarrubias De
Gutiérrez, Exc.^ma Empleada de la Ill.^ma Biblioteca del
Palacio de Minería en la Capital de esta N^va Esp.^ña. Invi-
tò y Llevò a V^tro Humilde Dibujante en el Mes de Marzo
del Año de N^tro S^r 1993 al Renombrado Mercado de So-
nora en la Misma Capital para Comer un Sabrosissimo
Consomè de Pierna.

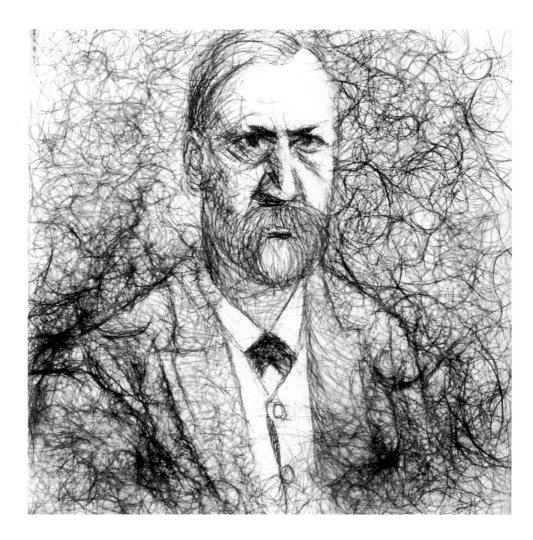

Margaret Morgan, *Portrait of Sigmund Freud as Feminine Sexuality,* 1993, pubic hair on linen, 8 x 8 in.

Facing page: J. Michael Walker, *Retrato de Doncella Guadalupe (Portrait of Lady Guadalupe Covarrubias de Gutierrez),* 1993, color pencil on paper, 50 x 38 in.

Currently transplanted to the Highland Park district of Los Angeles, Arkansan J. Michael Walker sojourned in Mexico as a young man, fell in love there, and married; he also embraced Mexican history and culture. A number of his works produced later in the United States update and incorporate the formal style and provincial seriousness of viceregal colonial Mexico—making him suspect in the eyes of some members of the Southern California Latino arts community. When shown south of the border, however, Walker's neo-

colonial portraits and fantasy narratives draw praise for their rich evocation of Mexico's layered and complex history. In *Retrato de Doncella Guadalupe*, his sitter, a librarian at Mexico City's Palacio de Mineria (a distinguished archive of antiquarian texts), is posed in a fictive scholarly setting reserved for the portrayal of great men in the colonial era. Beneath her is the traditional chiseled faux-monument that traditionally contained superlative praise of the portrait subject. In his image and text, Walker has inverted the genre

to deflate its usual pomposity by placing the humble and gracious mestiza librarian in the seat of learning.

Reconfiguring history is also the task of Margaret Morgan's small *Portrait of Sigmund Freud as Feminine Sexuality*. The depiction of the scowling, bearded patriarch earns its piquancy from the female pubic hair that makes up the "drawing" and resonates with the erosion of the psychologist's reputation over the past twenty-five years.

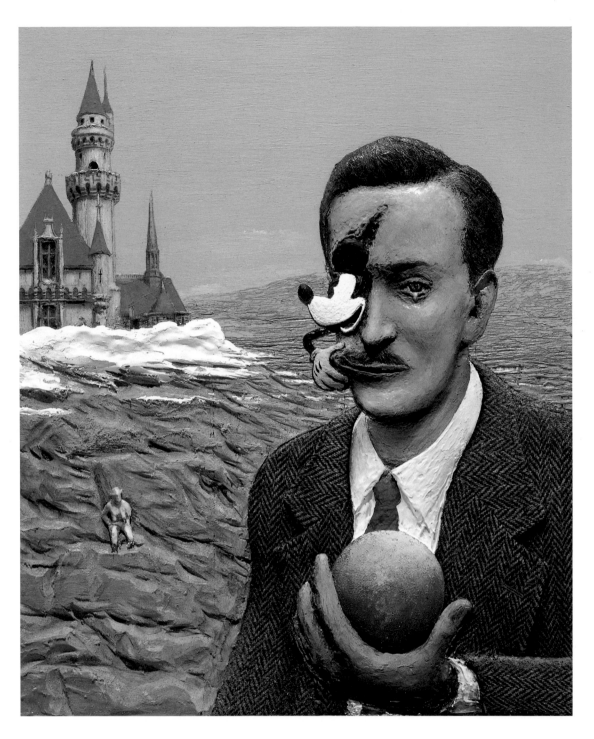

Llyn Foulkes, *To Ub Iwerks (Portrait of Walt Disney)*, 1995, mixed media, 25 -1/2 x 22 -1/2 in.

Llyn Foulkes brings history home to Southern California in *To Ub Iwerks (Portrait of Walt Disney)* from 1995. A mixed-media work that models the subject in low relief and uses actual tweed cloth for Disney's jacket, its title refers to a little-known, early pioneering animation associate of Disney. A number of film historians credit Iwerks' draftsmanship and technical wizardry for saving Disney's foundering animation business in the 1920's. In later years, Disney was suspicious of Iwerks (who won two Oscars and died in 1971; Disney died in 1966) for supposed disloyalty and was reluctant to credit him for his long-standing artistic contribution to the film studio. In Foulkes' critical and bizarre portrait — set against a barren landscape surrounding a sinking, snowbound Fantasyland castle —a tearful Disney seems to ponder what gaining the world of commercialized make-believe has profited him.

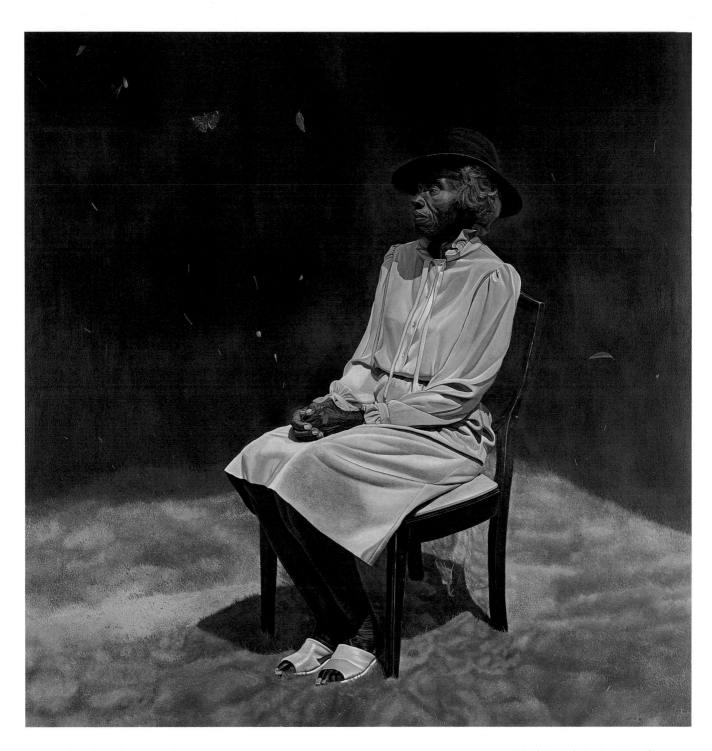

Portraits that abjure history to take a more personal approach include Craig Atteberry's miniscule, monochromatic, straight-on portrait heads that appear as apparitions on their large sheets of paper (*Chris*); Richard Wyatt's *The Survivor*, in which an elderly black woman becomes an emblem of the special dignity needed by countless others of her generation and station; John Sonsini's languid, yet hypercharged *Gabriel*, one of a series of

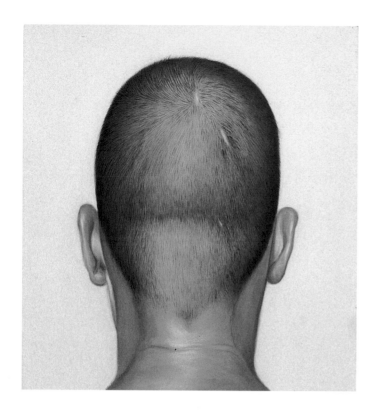

Salomon Huerta, *Untitled Head*, 1997, oil on canvas, 12 x 11 -1/4 in.

Facing page: John Sonsini, *Gabriel*, 1998, oil on canvas, 30 x 24 in.

expressionist portraits based on the same model that subtly and unselfconsciously portray gay desire; Sarah Perry's *The Miracle*, a goofy crossing of science and the supernatural in which the face of Albert Einstein has "mysteriously" appeared on a tortilla; and Lance Richlin's neo-academic rendering of his intense friend (*Portrait of Tom Bierce*).

Tijuana-born Salomon Huerta, one of the younger artists discussed here, recently became a local art world sensation with his truly innovative portraits of the *backs* of closely shorn heads of young men (see also *Identity and Self*). In the absence of a face for the viewer to query, Huerta's highly crafted and tight rendering of each bristly hair on his subjects' individualized heads disturbingly invites phrenological interpretation, that long-discredited pseudoscience which attempted to link the shape and bone structure of the skull to predictable character traits.

Lance Richlin, *Portrait of Tom Bierce*, 1996, oil on canvas, 24 x 20 in.

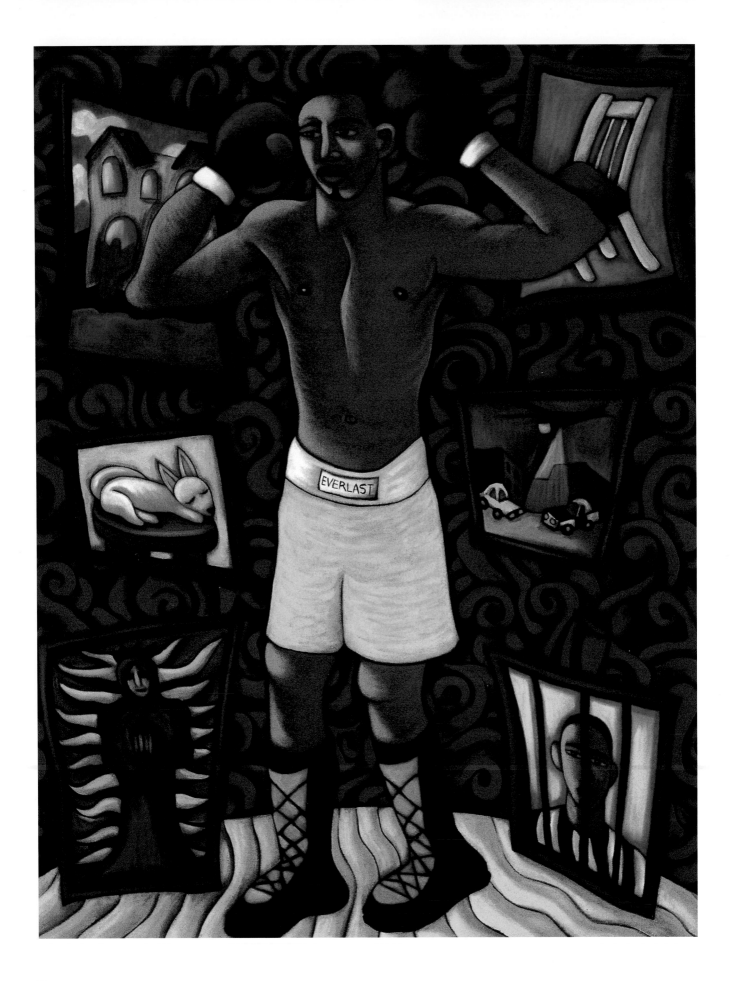

IDENTITY AND SELF

Portraiture also got a boost in the 1980s when it became driven by ethnic and gender studies in college and university art departments, resulting in a "politics of cultural identity." Much of this art had an activist or community focus and found support in the previously arts-deprived communities of East and South Los Angeles. It also meant that for a number of artists — originally Black and Latino, later Asian — ethnicity and history were the most viable subjects for their work. Chicano Art had its heyday in this period and now has pretty much joined the artistic mainstream of Southern California art via museum and gallery exhibitions, as well as through the presence of Latino artists on the faculties of a number of local college and university art programs.

In addition, figuration in painting, drawing, and sculpture has long enjoyed respect in African-American and Latino cultures, and it was this mode that dominated the production of the artists from these communities. This often caused friction in academic art programs. Young Latino and Black art students wanted to pursue traditional art training and demonstrated a distinct lack of interest in the abstract, minimalist, or conceptual modes that were *de rigueur* with the middle-class white faculty in so-called cutting edge art departments. A large number of minority artists saw traditional art training as the best way for them to represent their communities and themselves.

Akin to identity — and more personal — is the sense of self. Psychology has been an important tool for self-understanding for the white middle class since about 1950, when it started to "go popular," and it spread to other ethnic groups by the end of the century. In addition, the recollection of people, events, and places in psychotherapy encourages visual representation. Sociology, too, has trickled down from academe to become part of the way we look at the individual in relation to society. It is no surprise that aspects of psychology and sociology have come to inform the work of a number of representational artists in Southern California, sometimes combining with issues of identity.

Judith F. Baca began her artistic career in the 1970s with a series of public murals and monuments that she and her staff continue to produce today. A populist and a progressive, her works depict history, society, ethnicity, and self — occasionally fusing them all. Her portrayal of Mexican-American identity in the pastel drawing *La Mestiza* is robust and accessible in the muralist tradition, depicting the "new race" that came about with the intermingling of the Spanish and indigenous peoples of postconquest Mexico. Blue-collar male Latino identity is the subject of Tony De Carlo's *His Everlast*, an acrylic on canvas. In a neoprimitive, decorative style, the self-taught artist has rendered an icon of working-class aspiration: the triumphant boxer. This path out of poverty and the barrio is tempered by possibilities pictured in insets at the fighter's left and right, some whimsical, some ominous.

On the other hand, it might be a stretch to assert that Salomon Huerta's dead-still rear

Judith F. Baca, *La Mestiza*, 1991, pastel on paper, 23 x 29 in.

Facing page: Tony De Carlo, *His Everlast*, 1998, acrylic on canvas, 20 x 24 in.

view of a standing youth (the seamlessly painted *Untitled Figure #1*) raises issues of Latino identity. Perhaps the figure does, but its surroundings are as void of cultural reference as De Carlo's image is packed with them. The figure's baggy attire, nondescript tennis shoes, and shorn head could place him in the rave or hip-hop scenes of Monterey Park *or* Malibu. In his arrested stance he resonates a kind of iconic presence for male adolescence.

Young males on the threshold of adulthood and its responsibilities are the subjects of Deni Ponty and Dan McCleary. Using an illustrative mode, chiaroscuro lighting, and lots of narrative detail, Dutch artist Ponty has no Postmodern aversions to the sentimental. *First Job* depicts a gangly youth with too-long shirt-sleeves and scruffy shoes. Rather than the back of a head, Ponty wants you to look into the young theater usher's eyes, to feel for him, to acknowledge his vulnerable humanity: he is, after all, looking at *you*, waiting for *your* ticket! If Ponty could be called a Pre-Raphaelite artist transplanted to 2000, no such thing could be said of McCleary, who

Salomon Huerta, *Untitled Figure #1*, 1997, oil on panel, 67 x 32 in.

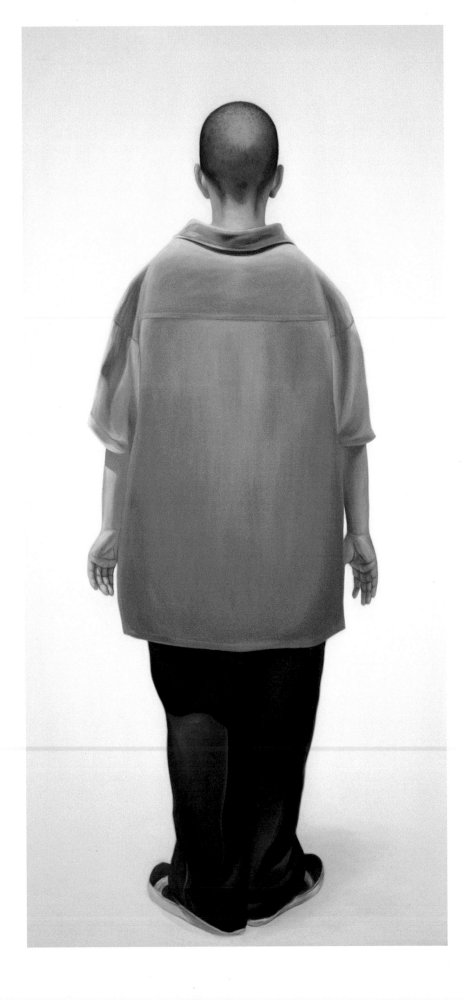

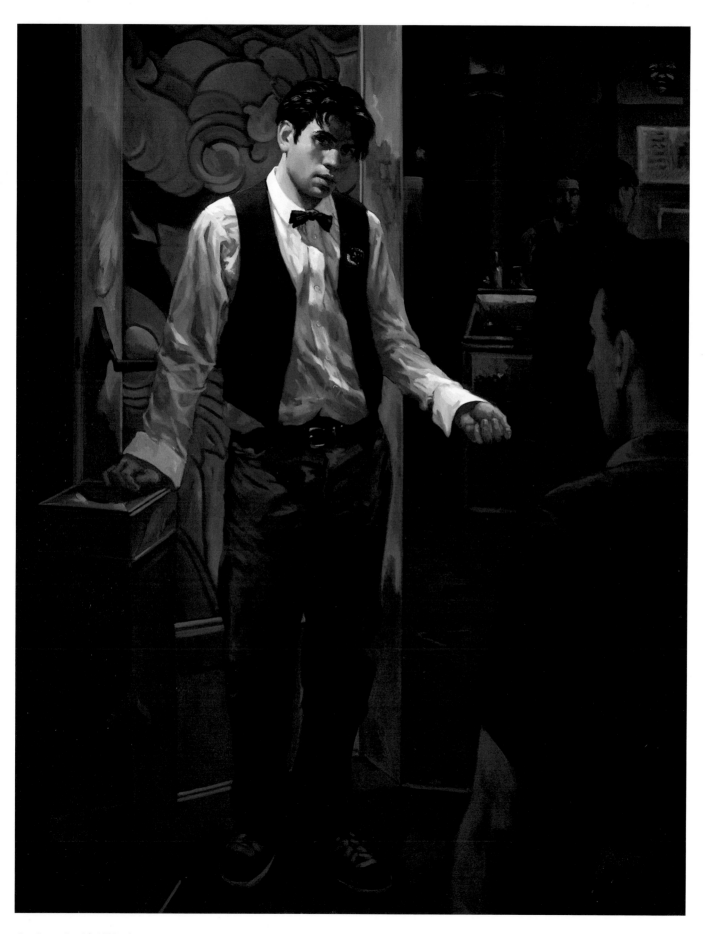

Deni Ponty, *First Job*, 1999, oil on canvas, 40 x 30 in.

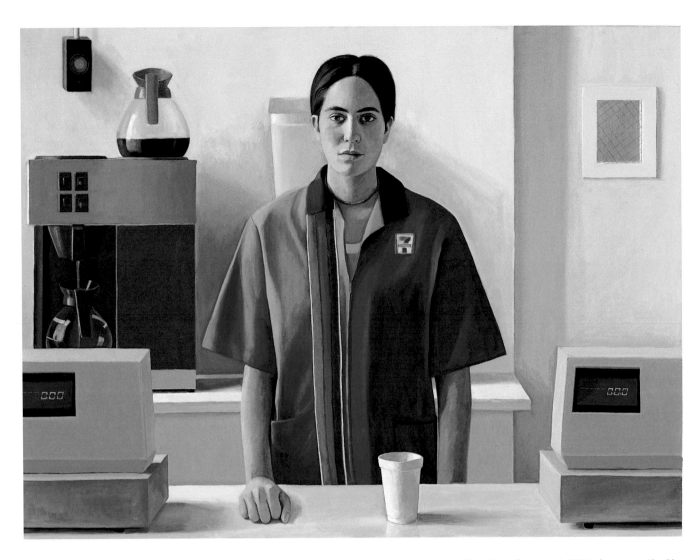

Dan McCleary, *Seven-Eleven, No. 2,* 1996, oil on canvas, 40 x 52 in.

views his scenes of ordinary life as formal constructions. In *Seven-Eleven, No. 2,* his young counterman betrays no affect as he waits for payment for a proffered styrofoam cup of coffee. His identity is virtually subsumed under the homogenous efficiency of the convenience store.

A few years ago, if you were to mention gay male identity and art in the same breath, what generally came to mind were the homoerotic caricatures of Tom of Finland and others of his ilk: hunky well-hung guys—adorned only with good-natured, come-hither grins. Outside this world of sentimental, breathless kitsch, serious art with gay themes was the sort of thing that straights gradually learned to intuit or had their gay friends "decode" for them. For all intents and purposes, its meaning was closeted from the straight world.

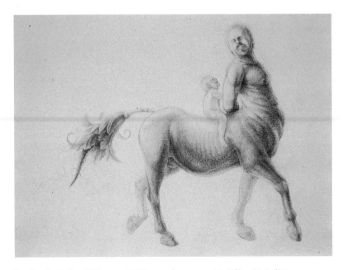

Tom Knechtel, *The Old Centaur,* 1993, pastel on paper, 22-1/2 x 30-1/2 in.

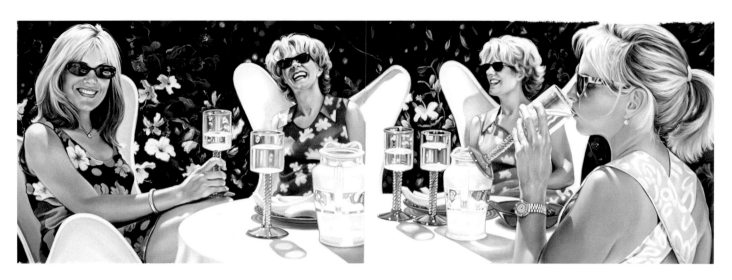

D. J. Hall, *Glee,* 1999, oil on linen, 14 x 42 in.

No longer. In Southern California in the past decade, a number of gay artists have treated gay identity (often after struggling to personally realize it) with compelling content and style. In fact, as a theme, their work is "out." Three works directly address gay identity and selfhood: John Sonsini's *Gabriel* (discussed previously in the *Portraiture* section), Tom Knechtel's *The Old Centaur*, and Roberto Gil de Montes' *Boy Indian*. The latter two are more intimate pieces from both artists' oeuvres. Knechtel has produced large, complex, but minutely crafted narrative paintings with layers of meaning that often weave gay life into the larger world, containing elements of the sacred and the profane. *The Old Centaur* is an autobiographical musing on an ancient

Roman sculpture seen while touring Italy. Gil de Montes has a propensity for dreamy, symbolic, and whimsical works; in his small, quick oil study *Boy Indian*, a slender youth with a towel around his waist and a necklace about his neck leans against the picture's edge, lost in reverie.

What passes for selfhood in some quarters of Southern California is ironically proclaimed in the color-saturated paintings of Venice artist D. J. Hall. In her ongoing series of paintings of thirty-something blondes at home in the Westside's dazzling light—with their orthodontically correct smiles, Fred Siegal clothes, north of Montana Avenue addresses (Santa Monica's toniest district), Smith and Hawken gardens,

Sunset magazine alfresco lunches, and invisible, high-salaried Industry (and you know which) husbands—we get the feeling that something is terribly amiss. A sense of dread seeps out of these sunny gatherings of happy, bubbly friends who seem to all look, think, and act alike—and never get old. The diptych *Glee* is Hall's image of overlush perfection that hopes to stave off grief, death, and illness.

Selfhood as an uneasy state of mind and being is imaged in the relationship-haunted narratives of Cynthia Evans (*Something Blue*), Robin Palanker's boxed-in and gender-dichotomized "figurines" (*Patience*), and Sharon Allicoti's series of interior/exterior metaphorical desert narratives (*Rear Window*).

Robin Palanker, *Patience,* 1994, pastel on paper, 41 x 51 in.

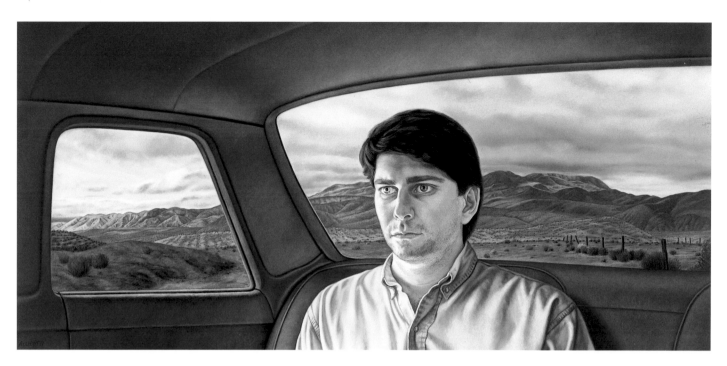

Sharon Allicoti, *Rear Window*, 1998, pastel on paper, 21 x 45 in.

Cynthia Evans, *Something Blue*, 2000, oil on panel, 10 x 7-1/2 in.

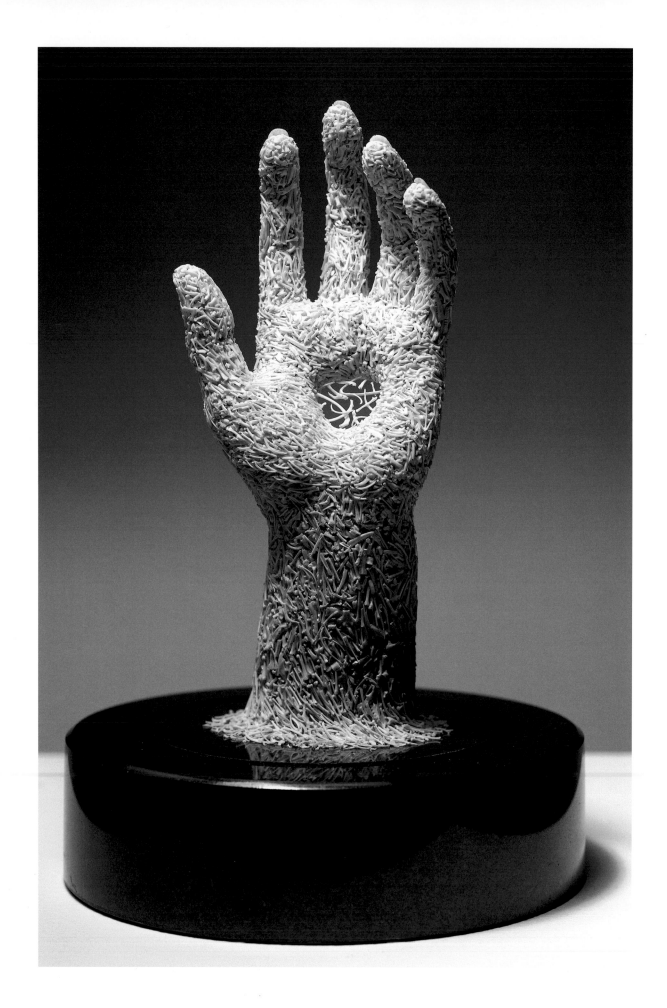

THE BODY

In researching this essay, much of the painting and sculpture I encountered that made the human form its sole subject (that is, treated apart from serving a larger narrative function) also significantly altered, fragmented, or occluded the human figure, or placed it in some kind of distress. When I did find complete figures, they were often drawn in timid sub-academic styles or without solid conviction. In sculpture, I found two tendencies: work so representational as to resemble shop window mannequins and, conversely, work where the deconstruction process had gone too far from its bodily referent. In painting, drawing, and sculpture it seemed that the most vigorous work engaging the body was that which eschewed the body's integrity and had strong ideas about why this was necessary to the work.

Easy theorizing could attribute this to the fragmented nature of contemporary American society and Southern California's special role in generating these centrifugal forces. This may account for part of the phenomenon, but I will suggest a more basic explanation: a number of the artists shown here have had to learn to draw the figure on their own. Rigorous, systematic education in the mastery of the figure was no longer a part of the studio curriculum when many of them were in graduate programs in the 1960s through the 1980s. Approaching the body in segments may be their best way eventually to reach a holistic understanding of the human form; they use it as a synecdoche.

Another reason may be that for the contemporary figurative artist, the whole body lacks the mystery or emphatic wallop of a partial corpus or a single member. Think of our admiration for ruined Classical statuary such as the headless, armless Victory of Samothrace or the surging vitality in the dismembered *Belvedere Torso* by Apollonius. We like to imagine completion for what is no longer there or visible, especially when the part is rendered with the kind of authority evident in the *Small Torso Painting in Yellow*, by Jim Morphesis.

The partial and whole figure is treated in the recent work of Dutch artist Tanja Rector. She is concerned with the body's dislocation in the contemporary world and occludes her monumental isolated figures and limbs with an overlay of translucent beeswax, suggesting the dissolution of the human form. Rector's *Untitled (Pregnant)* has its counterpoint in Kymber Holt's *Untitled (Ovaries)*, where the miniaturist's exactitude creates a high-focus floral sensibility in her depiction of female reproductive organs. The ovaries are arrayed against a wallpaper-like field of complementary decoration, uniting nature and artifice.

Facing page: Sarah Perry, *Darwin's Portal,* 1997, bones, granite, jute, and copper, 11 x 7-1/2 x 7-1/2 in.

Jim Morphesis, *Small Torso Painting in Yellow,* 1999, oil on gold-leafed panel, 17 x 12 in.

The simultaneous disappearance and appearance of the human form has been a hallmark of the sculpture of Robert Graham. In a time when serious figurative sculpture was scarce, Graham's mastery of aloofly perfect and coolly eroticized depictions of nubile young women coincided with the ascent of a feminist critique of the male gaze and its objectification of its female subject. Concurrently, critics disparaged the viability of "the statue" in contemporary art. Graham's frieze of female nudes in relief (*Untitled – Series V*) from the base of his Duke Ellington memorial sculpture shows lithe female forms emerging from or receding into a flat plane. None are represented whole. While they may seem at once sensual *and* distant to the North American eye, Mexican-born Graham's 1997 retrospective in Mexico City was appreciated for his sensitive "idealizations of woman."

Another kind of diminishment of the sensual body occurs in *The River,* a work by Cuban-born Enrique Martinez Celaya. A cast made from a female model is used as a backdrop for a painted landscape and sky and suspended high on a wall above the gallery floor: the body as metaphor for, or even part of, nature. *The River* has an affinity with Alison Saar's mythic, expiring man *(Terra Firma)* done in a folk art vernacular. His labor done, his life over, he sinks into the earth from which he came.

During the past decade, painter-sculptor Peter Zokosky (see also *Portraiture*) has tried, so to speak, to get under the skin of the human form. In his flayed and flaying images, he and his once-ideal figures seem to be asking where the spirit or soul resides in the "animated meat strung on bone" we call human (a painting and a bronze, both *Untitled*). Zokosky's counterpart in this approach is the Glendale draftsman David Limrite, who makes charcoal and graphite figure drawings con brio, leaving vital human organs and the skeleton visible as a way to reckon physiologically with deeply held emotions, such as remorse or anger (*Drowned Anger*). His work is an inner and outer record of the spirit in turmoil. Like Zokosky and Limrite, sculptor John Frame has

Kymber Holt, *Untitled (Ovaries)*, 1998, oil on panel, 6 x 27 in.

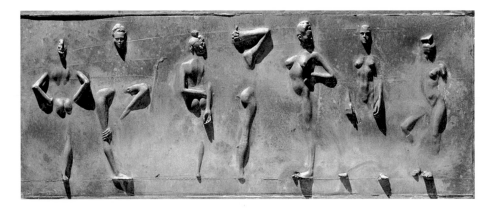

Robert Graham, *Untitled – Series V,* 1992, cast copper bas-relief, 48 x 19 x 1-1/2 in.

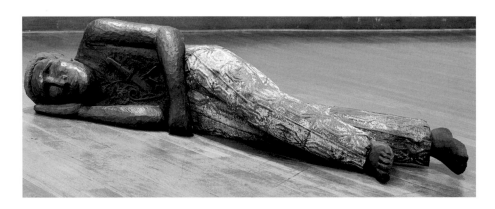

Alison Saar, *Terra Firma,* 1991, mixed media on wood, 18 x 74 x 22 in.

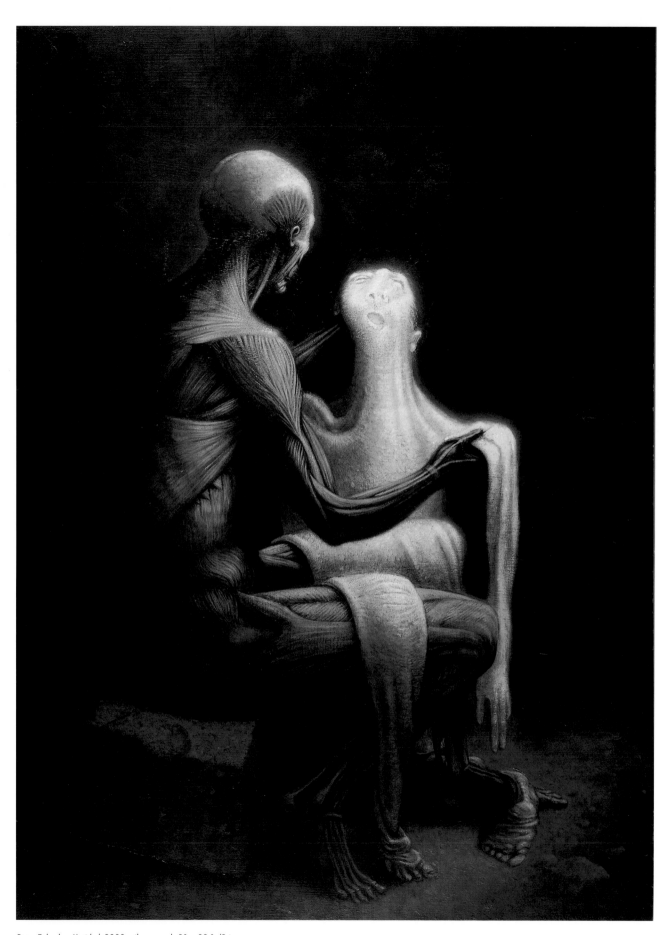

Peter Zokosky, *Untitled*, 2000, oil on panel, 31 x 22-1/2 in.

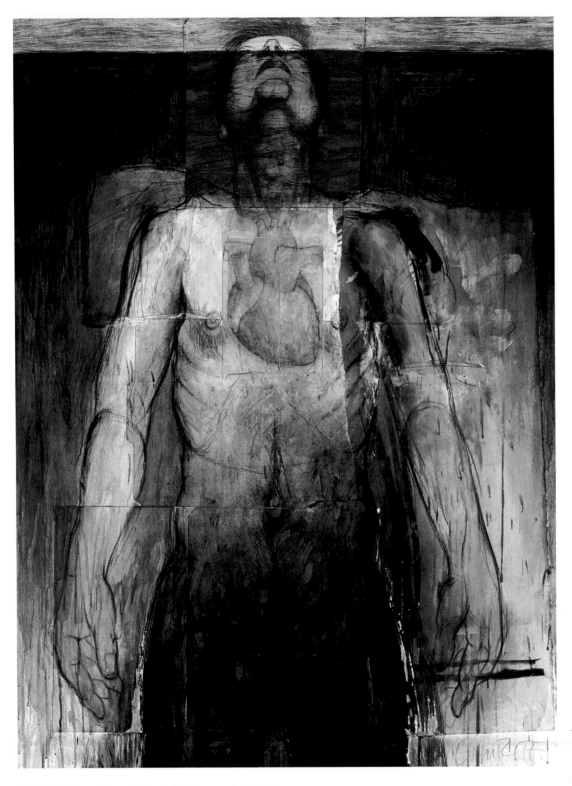

David Limrite, *Drowned Anger,* 1998, mixed media on panel, 48 x 36 in.

created figurative work that emphasizes the body as a kind of noble but vulnerable construction. His figures are often cobbled together from disparate parts or have parts missing. Nevertheless, they retain a vital and psychological force even when missing a head, both arms, and a foot *(Poor Tom)*. They soldier on just the same.

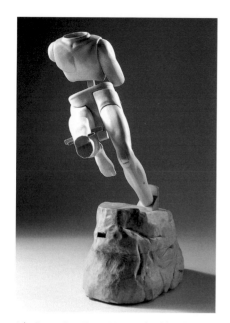

John Frame, *Poor Tom*, 1997, wood and found objects, 17 x 9 x 9 in.

Single body fragments that project a startling, signifying presence are represented here in works by Leonard Seagal, Brian Mains (see also *Spirit*), Tanja Rector, Enrique Martinez Celaya, and Sarah Perry (see also *Portraiture*). In the twentieth century, fascination with the use of a single body part eventually led to the devolution of this motif to mere poetic conceit or device. As a result, these artistic devices were gradually drained of their original power. The artists cited above have produced work that restores the power of these images. In 1999, Rector did a series of small panels of isolated hands, either clasped together or as individual members, depicted against light pastel backgrounds and made out-of-focus through a beeswax overlay. Seen serially, they are hopeful images, evoking the emergent potential for meaningful gesture, resolve, or action.

A fresh use of the body as fragment occurred when Leonard Seagal, on a residency at the John Michael Kohler Foundation, made ductile iron casts of his forearms, legs, and one complete arm. For the legs and arm, he hinged the joints at the knees and ankle, elbow and wrist. Seagal avoided the obvious risk of an association with robotics by his attention to the body's delicacy in the precision of the casting. *One Arm, Multicolored Love Beads,* is

slightly raised at the wrist by a string of "love beads" suspended from the ceiling, giving definition to the space above the work and allowing the fingers to barely graze the pedestal, as if touching piano keys. The contrast of the bright beads with the dully burnished iron produces a gesture of subtle and surprising grace. In *Darwin's Portal*, Sarah Perry brings together the scientific and the metaphysical with a single upright human hand constructed of thousands of tiny reptile and amphibian

bones in various states of decay. The hole in the palm, the portal, invites us to ponder it as the place where evolution and entropy find their balance. Likewise, transition and disintegration are placed side by side in Brian Mains' darkly religious display of two severed legs that cast a single shadow between them (*Untitled*). Celaya's *Spirit,* a severed head made from clear but tinted cast resin, is an elegiac meditation on loss, mournfully aglow with soft amber.

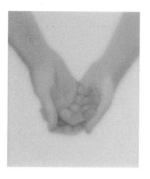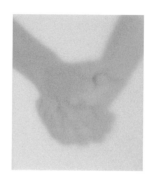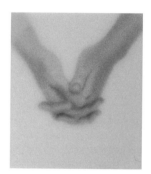

Tanja Rector, *Hands Series,* 1999, oil and wax on panel, 15 x 13 in. (each of three panels)

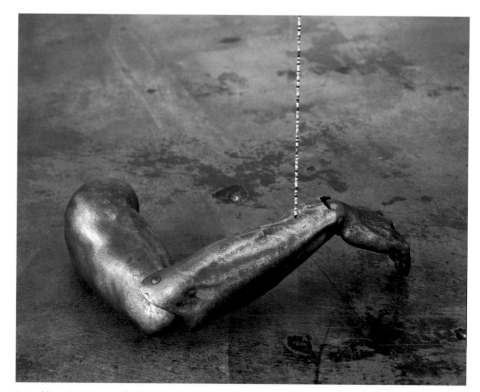

Leonard Seagal, *One Arm, Multicolored Love Beads,*1998, cast ductile iron, glass love beads, 6 x 14 x 19-1/2 in. (lifesize with vertical bead string)

NARRATIVE

By and large, fine arts education in Southern California between 1960 and 1990 did not offer complete curricula in foundational programs, that battery of sequentially integrated courses in drawing and painting based upon the mastery of rendering plastic forms and nude models. The legacy of the nineteenth-century art academy in both the United States and Europe, these courses were fairly well represented in art school curricula into the mid-twentieth century. Up to that time, foundational coursework sought to prepare students to make art of greater complexity; that is, if you could draw *one* figure, you could by extension place a number of them in your composition, forming a visual narrative. But with the rise of free-form and more individualistic modes of instruction (as well as art world trends that found traditional art coursework irrelevant) integrated, foundational coursework was eroded and undermined in the studio curriculum. A particular anecdote is worth retelling: during the 1970s at California Institute of the Arts, Valencia, one drawing class was encouraged to throw bits of wet clay at the model. And while foundational courses did survive in this period, they tended to be offered piecemeal and were increasingly taught by part-time faculty.

As a result, students who wanted to learn how to draw, paint, and create figurative sculpture had to teach themselves, which was the case for many of the artists discussed here. The situation, however, has turned around to some degree in Southern California. To name a few of the better known schools, strong foundational programs exist at the Otis College of Art and Design, Los Angeles; and the Art Center College of Design, Pasadena. In Laguna Beach, the Art Institute of Southern California is almost exclusively dedicated to foundational art instruction.

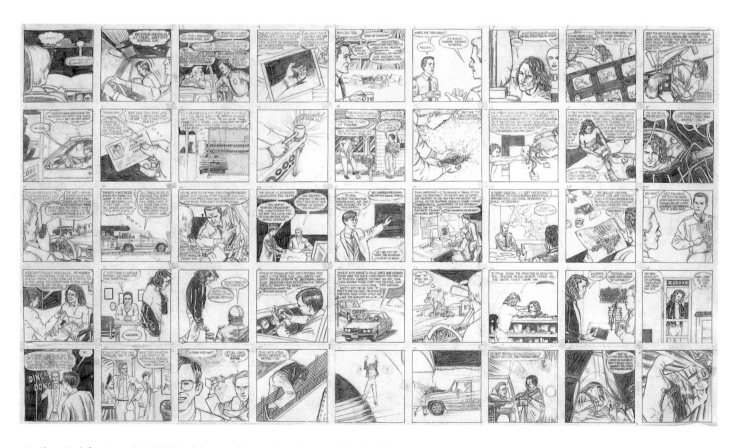

Jim Shaw, *Study for a Horror Vacui,* 1991 (with Benjamin Weissman), pencil on paper, 21 x 38-1/4 in.

Facing page: Anita Janosova, *Coming of Age,* 1993, oil on linen, 94 x 72 in.

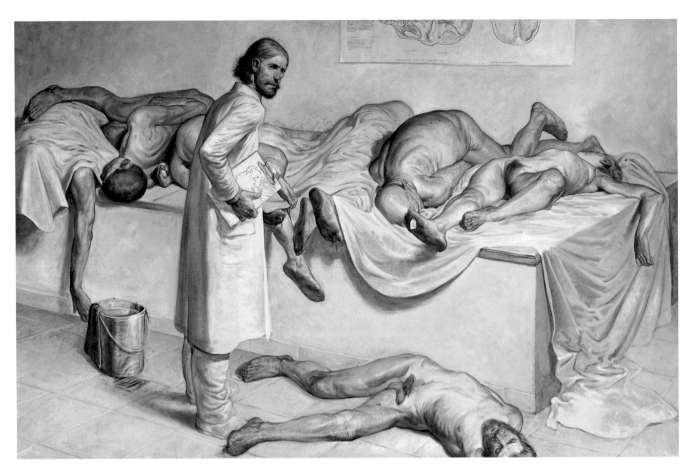

Ruprecht von Kaufmann, *Requiem,* 1998, oil on canvas, 69 x 96 in.

Whatever the tenor of art school instruction, there have always been informal sources for figurative study beyond academe. Then and now, young aspiring artists have gained basic skills by copying "superhero" anatomy from comic books and more complex compositions from the higher-end graphic novels. And whatever else comics do, they are bound by convention to place the figure in a narrative format. The comic genre has been a major influence on Los Angeles artist Jim Shaw, who uses it to construct dark, nightmare narratives loosely connected to notorious crimes (*Study for a Horror Vacui*). Likewise, Briton Christopher Finch, who resides in Los Angeles, deploys the Sunday newspaper comics format to construct amusing, if disjunctive, narratives. His *Good Girl, Bad Girl, Tiki Room,* is a

hilarious send-up of the mystique of the New York School and the art critics that supported it, Clement Greenberg and Harold Rosenberg.

Many of Southern California's figurative artists will tell you that the work of the Norwegian painter Odd Nerdrum is a great source of encouragement for them. Nerdrum's bleak, neomedieval tableaux astonished the international art world with their bravura draftsmanship and emotional intensity. His skill, angst, and self-description as a "kitsch artist"— strategically embracing a disparaging term the late Clement Greenberg reserved for artists persisting in figurative styles—inspired a number of American artists in their representational vocation. Locally, the young Ruprecht von Kaufmann (see also *Still Life*) shows traces of

Jorg Dubin, *The Wait*, 1998, oil on canvas, 35 x 41 in.

Nerdrum's influence. *Requiem* has all of the pessimism of the Scandinavian and was conceived concurrently with the ethnic cleansing occurring in the Balkan civil war. The white-coated orderly standing before a display of flung corpses seems to question the viewer's complicity. A similar but more theatrical sensibility exists in Jorg Dubin's morbid study *The Wait*.

Among the more surprising developments in the return of representational art has been the non-ironic recycling of art historical conventions in pictorial art. Domenic Cretara, professor of art at California State University, Long Beach, uses neoclassical canons to organize the domestic scene in *Caretaker*. In a different mode, Aaron Smith has adapted cautionary moral and hygiene verse from Victorian texts aimed at children to construct his narrative. Victorian sentiment is wedded to the chiaroscuro and emotionality of the Baroque painter Caravaggio (*The Little Glutton*). Nineteenth-century painting with mythological overtones seems to inform Anita Janosova's

Domenic Cretara, *Caretaker*, 1999, oil on canvas, 66 x 84 in.

Aaron Smith, *The Little Glutton*, 1998, oil on panel, 36 x 27 in.

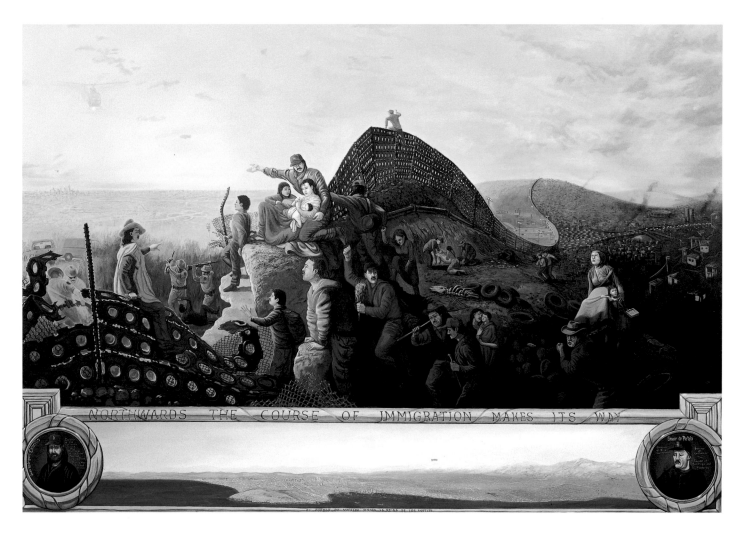

Sandow Birk, *Northwards the Course of Immigration Makes Its Way*, 1999, oil and acrylic on canvas, 65 x 96 in.

Randall Lavender, *Creation/Extinction*, 1992, oil on panel, 24 x 22 in.

highly wrought *Coming of Age*, an allegory about the loss of girlhood and the terrifying arrival of female sexuality. Randall Lavender's *Creation/Extinction* is a quieter but didactic allegory suggesting Renaissance and Baroque sensibilities.

Given the rich complexity and daily drama of Southern California life, one wonders why more representational artists haven't taken that content as the basis of their work. Some have, and the results have been rewarding, perhaps no more so than in the work of Sandow Birk. A thirty-six-year-old "surfer artist" who has become an art world phenomenon, Birk fuses compositions from great paintings in art history with the depiction of current social issues and events in Los Angeles. Borrowing from Emmanuel Leutze's 1860 proclamation of manifest destiny, *Westward the Course of Empire Makes Its Way*, Birk produced

Northwards the Course of Immigration Makes Its Way, a work that is simultaneously serious and humorous. The artist relocates the landscape from the Western frontier to the fenced California-Mexican border. Amid the squalor of trash heaps and squatter settlements, a cluster of Mexico's hopeful poor prepare for their illegal crossing. In the background, border police capture and beat a transgressor. The goal is in the gilded distance where the Los Angeles skyline beckons. Below in a predella, Birk has painted an idealized aerial view of Southern California, from the blue shores of its coast to its snow-capped mountains.

In this vein, too, is Thomas Stubbs' witty *Reconnaissance over Laguna Beach*, an allegory in which cherubs (along with F-18 Hornet jets from the nearby Marine air base) frolic in the sky above Laguna Beach. A bit of

John Nava, *2nd of May at Los Angeles,* 1992, oil on canvas, 78 x 120 in.

Facing page: Thomas Stubbs, *Reconnaissance over Laguna Beach,* 1994, oil on panel, 24 x 20 in.

an obscurantist, Stubbs meant to comment on the city's recovery after fires, floods and mudslides. Entirely serious, however, are history paintings by John Nava and F. Scott Hess. The tragedy of the 1992 Los Angeles riots is commemorated in Nava's classicized, hushed elegy *2nd of May at Los Angeles.* In Hess' allegory *Renovation* (which also refers to a humanist virtue admired in antiquity and the Renaissance), the subject is nothing less than the rebuilding of the "house of art." With a plumb line symbolically strung for true measurement, the scene is set on a hillside lot in the Echo Park area of Los Angeles, with the artist's friends as construction workers.

Richard Shelton and Gary Geraths are artists who tell the story of contemporary urban life in Los Angeles as momentary witnesses. *Call-*

ing the Chosen, which is in the style of a wide-angle, freeze-frame photograph, pictures the downtown financial district not far from Shelton's studio. A single "prophet type" in a business suit is preaching in the midst of a plaza of bustling corporate workers, proclaiming a message that they choose not to hear. Geraths, on the other hand, spent a season in the downtown superior court as a nonofficial sketch artist during the murder trial of O. J. Simpson. He got to know virtually all of the principal and subsidiary players in the case. Historically, his sketchbooks may come to be among the most important source documents of this sensational event. The most telling sketches are of the activities of the media and how they structured themselves to cover the trial.

F. Scott Hess, *Renovation,* 1997, oil on linen, 48 x 64 in.

Richard Shelton, *Calling the Chosen,* 1997, oil on canvas, 48 x 84 in.

Mediated communication is the metaphor underlying Christian Vincent's noir-surreal Self-Projectin. The hieratic composition of two nearly identical men "facing off" with film projectors on their shoulders, transmitting ethereal, luminous text spirals on each other's faces, is an apt image from America's film capital. That nothing of permanence or meaning is being said is symbolized by the blank pages of the open book on the table in the foreground.

Whimsical narrative with dreamlike under-currents informs the sculpture of Annette Bird and the painting of Ann Chamberlin. In Bird's *Emerging II*, the grayish cast of the mysterious, disparate quartet evokes the dim world of slumbering dreams. Chamberlin's primitivist *Talk Show* is a nervously funny, low-tech production (note the exposed sound wires) that exudes gender issues within an unclear scenario where everyone but the anxious dreamer seems certain of his or her place.

Annette Bird, *Emerging II,* 1997, bronze and wood (edition of six), 12-1/2 x 6-1/4 in.

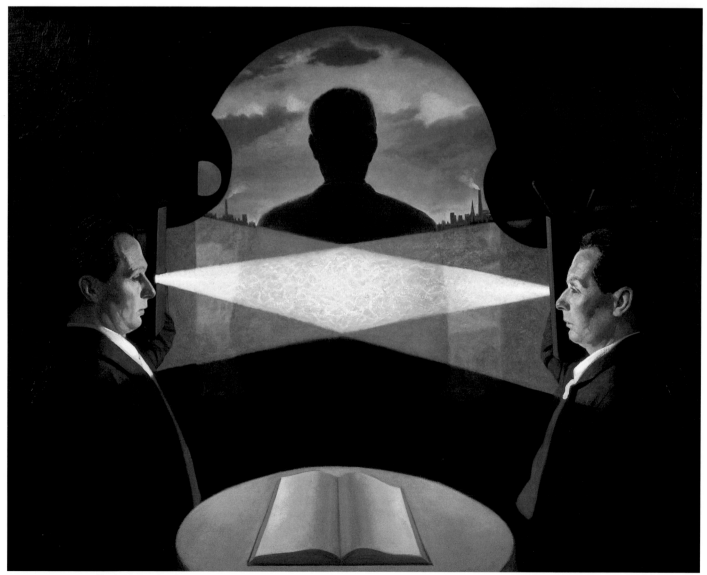

Christian Vincent, *Self-Projection,* 1997, oil on linen, 56 x 70 in.

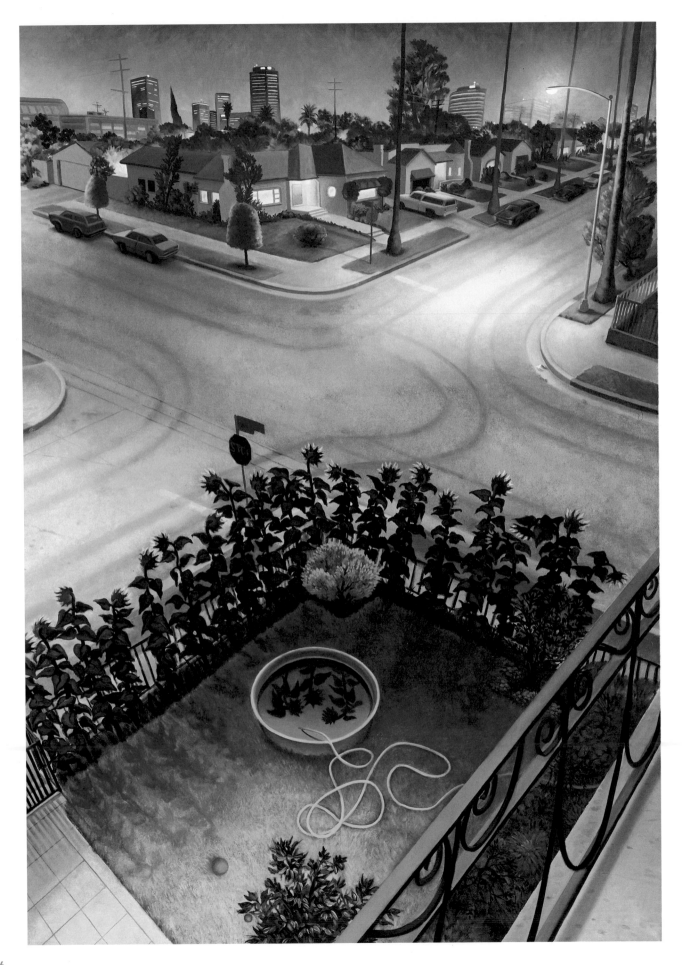

CITY

Owing to Southern California's ever-expanding suburban housing tracts, the area has been automobile dependent for the last half century. This has discouraged the development of the area's urban cores and street life that has traditionally been part of a mixed-use downtown. Despite some spotty (but successful) restorations of inner-city areas and the revitalization of pedestrian zones within certain older city blocks, the region still lacks centralizing spaces for social and commercial life. As a result, the visual sense of Greater Los Angeles is that of a place one drives through (or, in some areas, around) or flies over rather than resides in. And the prospect of having a breakdown in the neighborhood suggested by Chaz Bojorquez's *El Desire, El Power, El Love in the U.S.A.* is for some just too frightening to entertain.

Nevertheless, this horizontal, gridded, and dynamic environment offers a rich range of novel content to artists. Only a surprisingly small number, however, have risen to the challenge, especially given the size of the Los Angeles art community and its institutional depth. One of the artists who have responded is Jonathan Burke, whose day job is dean of fine arts at the Art Institute of Southern California in Laguna Beach. His aerial view as if seen from one of our ubiquitous TV-news "telecopters"—shows a city resembling downtown Los Angeles with serpentine freeways jammed with traffic and catastrophic vehicle collisions. The source of trouble in *Tie-Up* appears to be a giant *Tyrannosaurus rex* that rampages across the city at upper left. By using a prehistoric beast à la Godzilla, Burke incorporates the notion of disaster and apocalypse that has become part of Angeleno lore in the twentieth century. Another aerial view with catastrophic overtones is Peter Alexander's *Saugus*. This time disaster is seen from a jet making its runway approach at night over a luminous grid—a fiery apparition hovers in the flight path. Alexander was one of the earliest Los Angeles artists to portray Southern California's visuality in contemporary representational terms. In the 1970s, he turned from his successful "Light and Space" minimalist work to drawing sunsets from his ocean view home in Santa Monica, repelled by the effusion of minimalist critical orthodoxy in the art journals. He caustically termed it "the worst bullshit I ever heard in my life" and committed himself to pictorial work.

Chaz Bojorquez, *El Desire, El Power, El Love in the U.S.A.*, 1995, mixed media on paper, 15 x 18 in.

Jonathan Burke, *Tie-Up,* oil on canvas, 36 x 48 in.

Peter Alexander, *Saugus,* 1998, digitally enhanced painting (editioned), 42 x 46 in.

Between the late 1980s and the early 1990s, Lauren Richardson made some of the more wry visual depictions of the Los Angeles cityscape. In *Eve's Garden*, she composes her aerial view from the second story of an apartment complex overlooking an intersection grid under a light-polluted night sky. The foreground is the locus of the visual drama: a small square of grass containing a child's pool, a coiled green hose, and a single red ball is fenced round with high sunflowers. The work, superficially grounded in the childhood

of the artist's real-life daughter, Eve, refers, of course, to the biblical Eden and the romantic notions of early twentieth-century real estate interests that portrayed Southern California as a "new Eden." *Eve's Garden* seems to suggest that what is left of that outmoded dream is tiny and still fraught with temptation.

Despite the out-of-control building and overbuilding on Southern California's land, Angelenos—if they took the time to look—still had some of the most beautiful skies on

the West Coast to contemplate. This sense of lifting one's eyes to the heavens informs the landscapes of Jim Murray and Darlene Campbell. Murray favors drawing on-site and finds the meeting of industry and nature to be one of the more remarkable features of the city's landscape. In 1990, he found an ideal composition in the Century Freeway Project, which cut through lower-middle-class suburbs east and west, dividing and isolating neighborhoods. Under dramatic clouds a single pylon is counterposed against a delicate,

James W. Murray, *Untitled (Century Freeway Project)*, 1990, charcoal on paper, 6 x 8-1/2 in.

newly planted palm tree (*Untitled, Century Freeway Project*). Of similar mind is the Laguna Beach painter Darlene Campbell, who is saddened and amazed by the rampant growth of commercial zones on former agricultural land and the deluxe suburbs mounting the hills of Orange County's former Irvine Ranch. Working in an intimate format and a deliberately archaic style that recalls Renaissance Venice, she contrasts a bombastic, neo-classical architectural column (the kind that announces the entry to each developer's tract) with a concrete pylon that arises out of a freeway cut, ironically set against a warm pastel sky (*Orange County Wasn't Built in a Day*).

Whether Southern California's skies are made of fleecy clouds or the milk of magnesia haze from a coastal marine layer, as they are, respectively, in Campbell's *Always Open* and Stephanie Sanchez's *Across the Street, Palm*

Stephanie Sanchez, *Across the Street, Palm Trees*, 1993, oil on panel, 8 x 14 in.

Darlene Campbell, *Orange County Wasn't Built in a Day,* 2000, oil on panel with gold leaf, 12 x 12 in.

Trees, one can't help but notice the largely paltry skyline of the arid region. In the flat, formerly agricultural areas one doesn't see the woodsy growth of the Northwest and East Coast; rather, these areas are casually filled in with transplanted palm trees, power poles, commercial signage, and the roof lines of single-story strip malls or unpretentious 1920s bungalows. The painter who most makes us think of the as-built Los Angeles environment is James Doolin. Like Peter Alexander, Doolin suddenly abandoned abstract painting in the 1970s in order to become what he terms an "illusionist." His views of sweeping freeway architecture under overcast or Santa Ana wind-blown skies have graced a number of book covers and illustrated numerous essays. But if Los Angeles is a state of mind waiting for yet another desire to be projected onto it, then perhaps Doolin's *Psychic* is its emblem. With a "Second Coming" firmament framing an empty billboard atop a low-rent storefront, it seems to cry out *YOUR* MESSAGE HERE!

Facing page: James Doolin, *Psychic,* 1998, oil on canvas, 54 x 36 in.

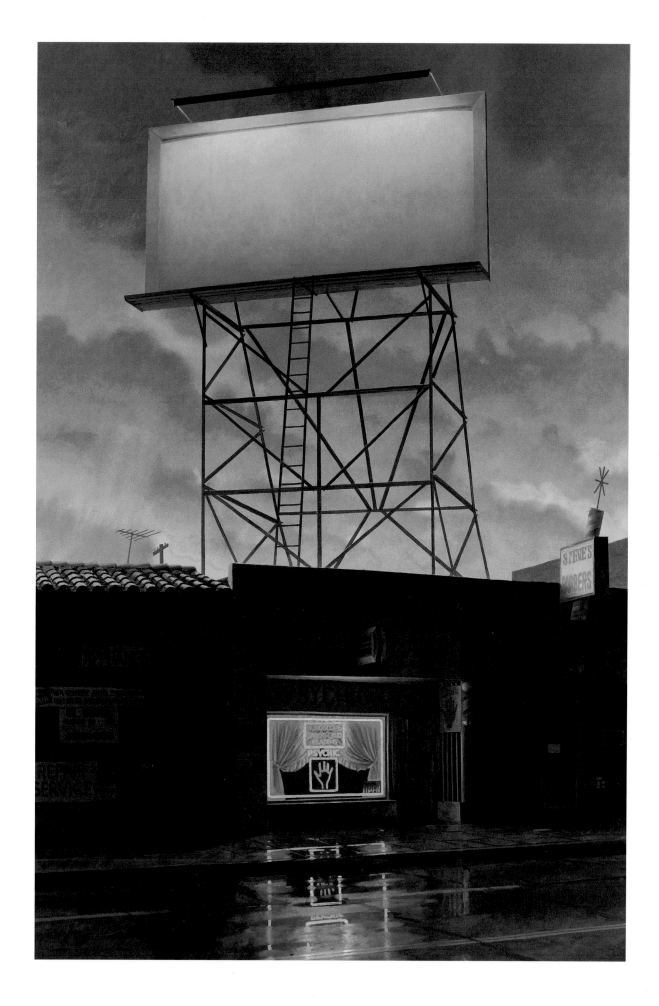

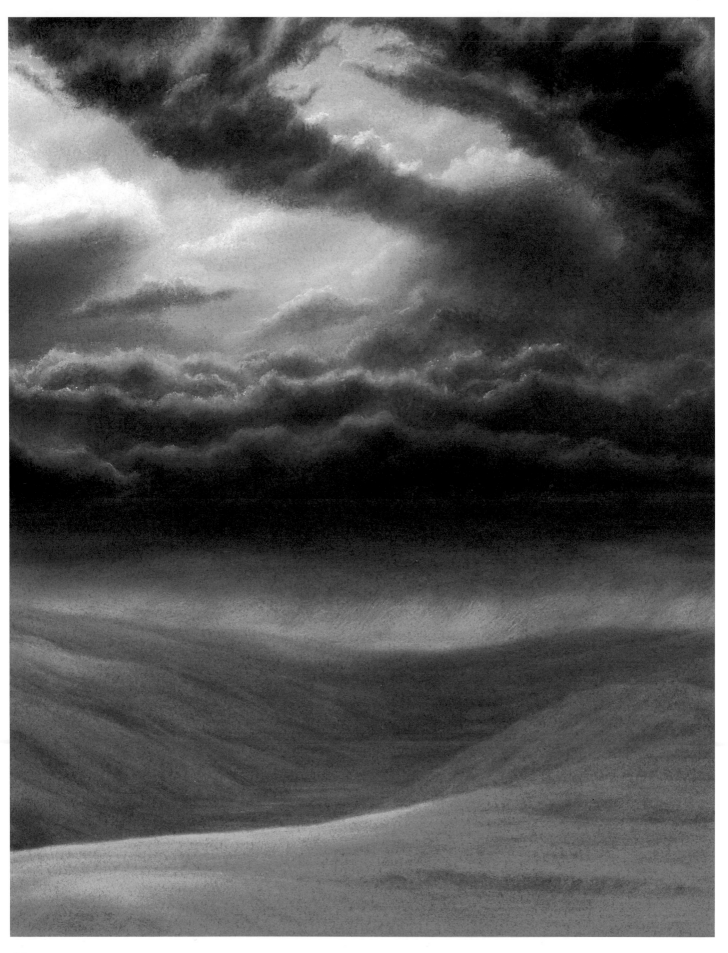

LANDSCAPE

It now takes longer to get into undeveloped land in Southern California and there is less of it—much less. If you are fortunate to live near the San Gabriel Mountains, however, you can be in the Angeles National Forest in fifteen minutes and have some respite from the teeming, dreaming, and scheming millions. Areas once thought safe from development continue to be lusted after by developers, who wield formidable power in local politics. And it looks as if the sprawl from Ventura County coming east will meet the sprawl from Los Angeles County moving west at the borderline, creating a virtually indistinguishable spread of suburban settlement north of the Santa Monica Mountains. Moreover, advances in engineering have allowed the arrogant rich to build houses on slopes and rocky promontories once believed inaccessible, obstructing scenic views with their palaces of privilege. If there is one wild sight on the land that still can be found in the few remaining wilderness areas *and* in the suburbs, it is the indomitable coyote, monumentalized in bronze by Gwynn Murrill *(Coyote VIII)*.

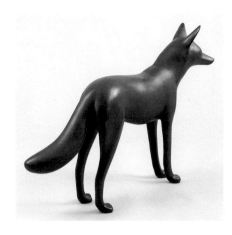

Gwynn Murrill, *Coyote VIII*, 1995, bronze, 30 x 47 x 10 in.

Facing page: Hilary Brace, *Untitled* (detail), 1996, pastel on paper, 18 x 32-1/2 in.

The places where luxurious human habitation encroaches on nature engage the Los Angeles painter Barrie Mottishaw. Her nighttime landscape *Mulholland and Coldwater* depicts the ridge top and canyon homes of filmdom's royalty in the Hollywood Hills. Darlene Campbell's small paintings (see also *City*) pack a real punch because they portray the leveling, scraping, and grading of hills of south Orange County as if these depredations were beautiful things to behold (*Moving Mountains* and *A Simple Truth*). Farther down the real estate ladder and farther away, a tackier, if less geologically destructive, kind of habitation for those "just passing through" is evident in the late John Register's *Motel by*

Barrie Mottishaw, *Mulholland and Coldwater*, 1997, oil on canvas, 11-1/4 x 17-1/4 in.

Darlene Campbell, *Moving Mountains,* 1993, oil on wood with gold leaf, 11 x 6-1/2 in.

the Freeway. Plunked down in the desert north of Los Angeles, it is depicted in sharp, clear light set off by long foreground shadows. The style and mood of the lonely *Motel* surely qualify Register to be the Edward Hopper of Southern California. Conversely, David Hines has built much of his career on painting the desert in and around Lancaster and Palmdale —at night. His work has a context: as land south of the San Gabriel Mountains became scarce and expensive, developers like billionaire art collector Eli Broad put tracts of houses on cheap desert land to the north. As more and more desperate middle-class families bought houses in the far-flung area (gaining three-hour work commutes with their investment), the once dark desert with its glittering vault of stars became less so. Hines is fascinated by the artificiality of street lights that illuminate empty intersections and the glittering, thin rows of lights from distant housing tracts scattered across the horizon of the desert floor (*204th Street/Ave. H, Lancaster*). Some artists, however, still want to represent the desert as desert. Rebecca Morales has recently done a series of plain-spoken, wide-horizon paintings of specific areas in Southern California's deserts. Committed to rendering these arid zones meticulously and respectfully, works such as *The Salton Sea with Smoke Tree and Ocotillo* exude a sobering stillness.

There are other artists who seek areas of undeveloped land and wilderness to paint. Bruce Everett, a professor of art at California State University, Northridge, abandoned photorealism in favor of *plein air* painting in the 1980s. He has become a master of that special

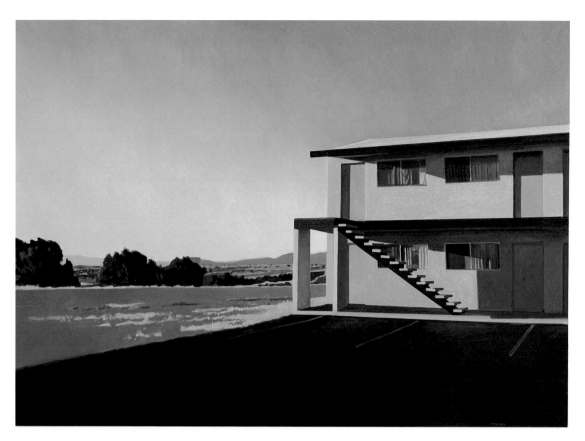

John Register, *Motel by the Freeway*, 1995, oil on canvas, 50 x 70 in.

David Hines, *204th Street/Ave. H, Lancaster*, 2000, oil on canvas, 24 x 36 in.

Bruce Everett, *Evening Haze,* 1998, oil on canvas, 48 x 72 in.

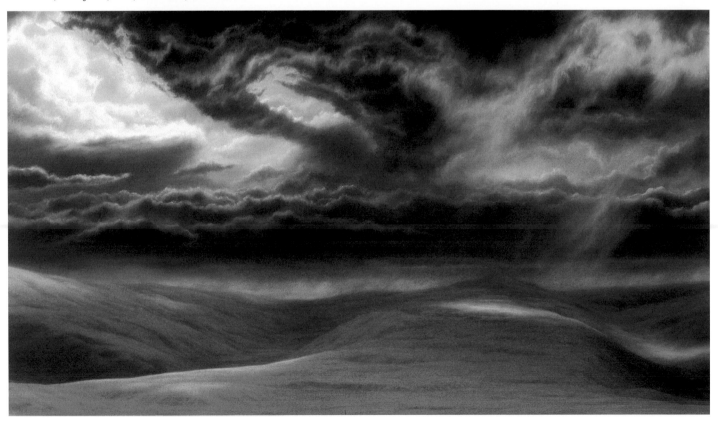

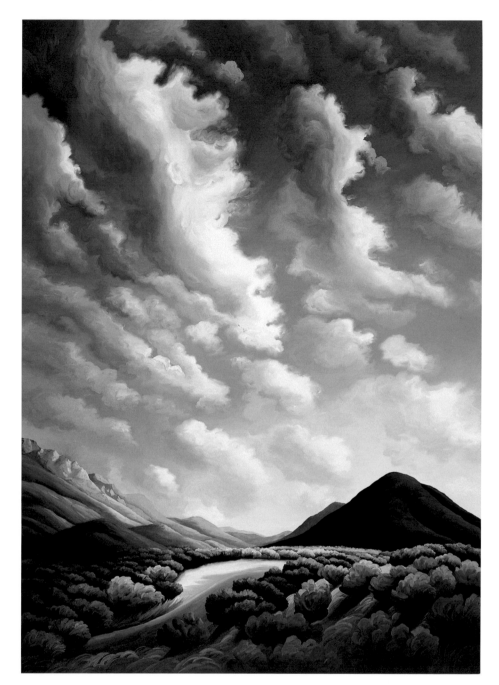

Phoebe Brunner, *Walk on Top,* 1999, oil on canvas, 66 x 48 in.

Daniel Wheeler, *Hole,* 1997, mixed media,
11 x 22 x 16 in.

Facing page, bottom: Hilary Brace, *Untitled,* 1996,
pastel on paper, 18 x 32-1/2 in.

quality of light that lends drama to Southern California's chaparral and its oak-strewn foothills (*Evening Haze*).

The landscape as repository for dreams and fantasy characterizes the works of two Santa Barbara artists, Phoebe Brunner and Hilary Brace. In *Walk on Top,* a deliriously skyward view loosely based on the hilly country above

Santa Barbara, Brunner has devised a reductive system of forms for clouds, hills, rocks, and shrubs that play off an electrified color palette. The painting's seductiveness is rooted in its synthetic quality, not in any commitment to capture a real place. The real dreamer, though, is Hilary Brace, whose pastel landscapes seem to be from a newly discovered planet (*Untitled*). Her mossy, rolling land has all the fluidity of water; her dark band of low-slung clouds suggests stepped mountains. Only God knows what to make of the sublime,

vaporous tempest crowning and soaring above it all.

Perhaps Daniel Wheeler's *Hole* can bring us back to earth. His conceptual sculpture is a footstool upon which rests an environmentally correct Birkenstock sandal from which grows an elegant miniature evergreen.

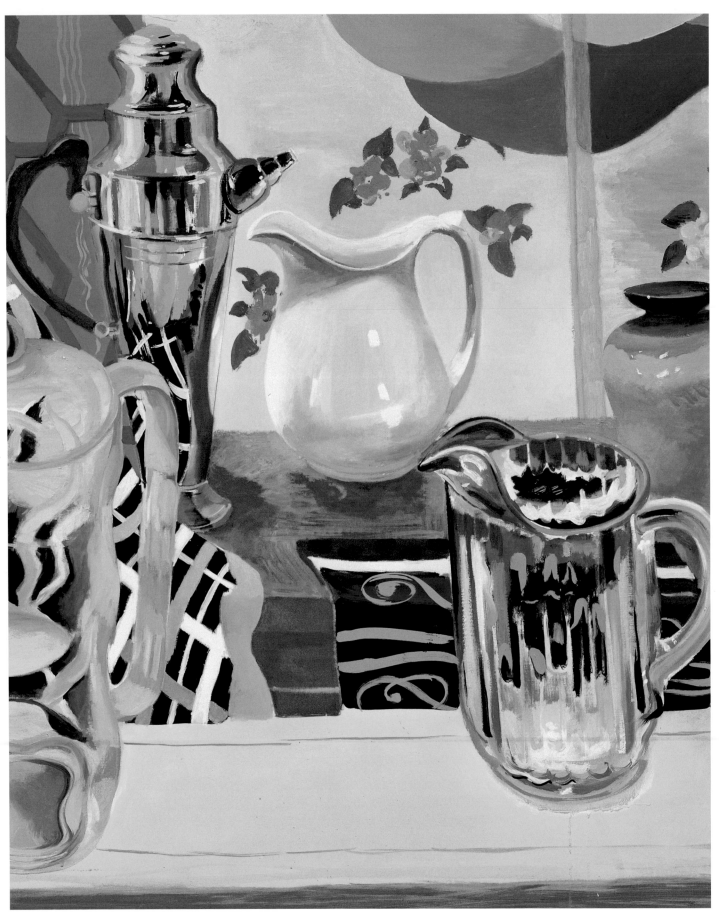

Les Biller, *The Lion Sleeps in the Sun* (detail), 1998, oil on linen, 48 x 60 in.

STILL LIFE

During the heyday of minimal and conceptual art it would have been hard to name a genre more disenfranchised than the still life (except maybe the seascape). Beginning art students generally haven't cared much for it either. For them, still life was an assignment grudgingly done to complete Drawing and Painting I. It was all an aspiring artist could do to keep from nodding off when staring at those monotonous arrangements of cylinders, cones, cubes, and spheres — or a bowl of fruit raked with a spotlight. But in the whirl of late twentieth-century art, what was anathema to one generation of artists is embraced by the next. And the young artist who was bored in the classroom later goes to a museum and sees a seventeenth-century Dutch still life by Pieter Claesz van Haarlem, or a Cezanne, or an Audrey Flack, and a light goes on. There's vitality in the genre after all.

There's a market for it, too. The figurative and representational revival in Southern California in the 1990s has been embraced by collectors yearning for art to adorn the home. After all, what is hung or placed in your corporate headquarters and office may be one thing; but what you hang in your home and *live with* is another. In choosing art for the home, the still life may have an edge over other genres. But that doesn't mean Los Angeles artists don't do edgy still lifes. A number of artists who earned their degrees from art schools with strong contemporary programs have found joy in rediscovering the traditional still life. Jeffrey Gold studied at Pasadena's Art Center College of Design and later committed himself to figurative and still-life painting. His most resolved piece in this genre is the glowing, hushed *Still-Life with Lemons*, in which he mastered the play of light on varnished wood, porcelain, linen, and citrus skin.

Jeffrey Gold, *Still-Life with Lemons*, 1996, oil on canvas, 27 x 21 in.

Nick Boskovich, *Heart of My Heart,* 1991, oil on panel, 5 x 7 in.

A colleague in this approach is Diane Fraser, who studied at the School of the Art Institute of Chicago before enrolling at that bastion of traditional art training the New York Academy of Art. Her *Peeled Orange* is a complex, luminous study of textures and reflections, shadows, and light. "The very thing itself" seems to be what Nick Boskovich is after in his tiny (5 x 7 inches), fussed-over *Heart of My Heart,* where the drama is fixed on a small table upon which rests a black vase holding a single perfect rose and an envelope just opened. The reflection of a person is evident on the surface of the vase. Also intimately scaled, but more casually poignant, is Enjeong Noh's simple composition *Still Life with Asian Pears* (see also *The Artist*).

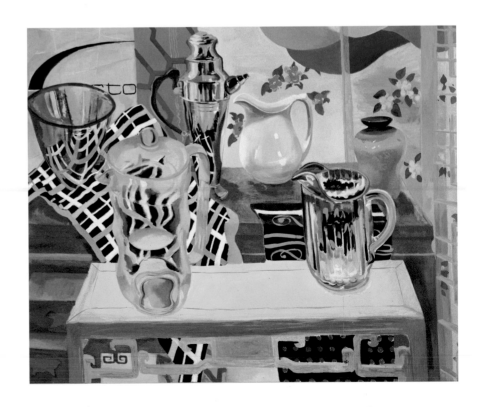

Les Biller, *The Lion Sleeps in the Sun,* 1998, oil on linen, 48 x 60 in.

Edgy and much less traditional are a series of recent large compositions by veteran artist Les Biller. In the obscurely titled *The Lion Sleeps in the Sun*, Biller has brought together a visual clash of reclaimed hip textiles, furniture, and vessels, all in artificial iridescent colors. The fun he experiences in painting the distortions of gaudy textiles seen through glass pitchers and vases is clearly evident. The composition brings to mind a display of wedding gifts appropriate to the tastes of a recently married Generation XY couple in the trendy Silver Lake district of Los Angeles. The still-life tradition is appropriated by Laguna Beach's Brad Coleman, who achieves historical distance by redrawing (in monochrome) four sections of still lifes by the eighteenth-century French painter Jean-Baptiste-Simeon Chardin. Coleman then overlays each section with a sumptuous hovering vegetable, capturing them in the moment of perfect ripeness before decay (*Four Vegetables, Four Chardin Details*).

Brad Coleman, *Four Vegetables, Four Chardin Details*, 1998, oil on canvas, 24 x 24 in.

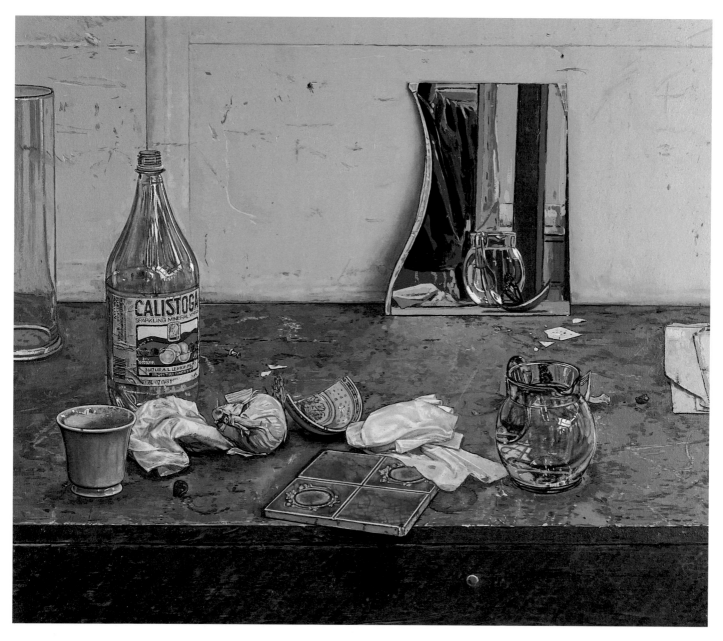

Emmanuel Cosentino, *Studio Still-Life I*, 1993, oil on canvas, 24 x 30 in.

Ruprecht von Kaufmann, *The Origin of Life*, 1998, oil on panel, 14 x 17 in.

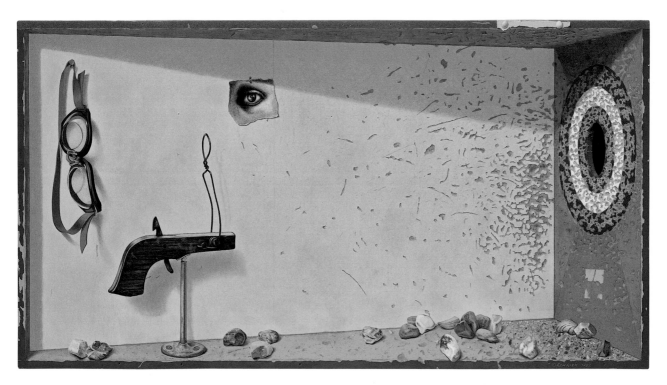

Ron Rizk, *A Site to Be Holed,* 1992, oil on panel, 17 x 36 in.

Manny Cosentino and Stephanie Sanchez bring disequilibrium to a tradition based on the attainment of exquisite economy and equilibrium. One imagines them rummaging through the trash can and other unkempt areas of their studios to create their compositions. Cosentino's *Studio Still-Life I,* a careful assembly of disparate objects on a work shelf, is actually two paintings in one: the large shard of mirror against the rear wall reflects the back of the little glass pitcher in the foreground and part of the studio opposite the composition. Sanchez, too, makes her arrangement on a work shelf. Painting in a loose, ephemeral style, it appears as if she has strewn the contents of a wastebasket around her half-eaten meal (*Garbage Still-Life*).

Ruprecht von Kaufmann, at twenty-six, the youngest artist presented here (see also *Nar-*

rative), favors strong symbolism in his brooding *The Origin of Life.* His composition concentrates on a female pelvic bone, an egg, two ripe stone fruit, and a teetering glass of red wine—perhaps emblematic of the fragility of human life. By contrast, the narrative trompe l'oeil of Ron Rizk, *A Site to Be Holed,* reveals an illusionist punster who likes to explore mystery, irony, and humor. Rizk draws his inspiration from odd, once-functional objects that he finds in junk stores and antique shops. With its antique toy gun and faux-fusilladed target, *A Site to Be Holed* is a whimsical meditation on seeing: note the picture of the eye tacked above the jury-rigged gun sight and the goggles hanging at left.

Kathryn Phillips, *Untitled* (from the *Spirit and Matter Series*),1998, oil on panel, 36 x 30 in.

SPIRIT

It is by now a cliché to remark on Southern California's receptivity to nontraditional and experimental religions. For over one hundred years, the newness of the region and its propensity to see itself as a place for personal experimentation on the western edge of the continent encouraged a more open-minded approach to religious matters. H. L. Mencken and other East Coast writers have satirized the extremes of spiritual credulity in Southern California, but seemed to have missed that which had spiritual depth.

In recent years, artists have noted the spiritual emptiness in contemporary American life. As a result, during the 1990s, artists introduced more spiritual and religious themes into their work. While abstraction has always been a mode open to the spiritual, whether in trying to image "the One" or evoking a sense of spirituality via mood and symbol, representational and figurative artists have found spiritual content more difficult to deal with. After all, how *does* one paint an Annunciation in the late twentieth century? How can one depict sacred subjects or narratives and remain contemporary? For a long time these and similar questions were taboo in the art schools. And most writers and critics were uncomfortable with, and indifferent or hostile to, the notion of contemporary spiritual or religious art, much less representation. But the temper of the times has changed and religious content has become more acceptable. Along with this change, a number of artists also discovered "spiritual places" that had been in Southern California all along. Such is the case of Peter Adams, a *plein air* artist who became aware of a small, low-ceilinged votive shrine at Mission San Juan Capistrano. His *Candlelight in St. Peregrine Chapel, Mission San Juan Capistrano* is a ruddily lucent impressionistic evocation of this spiritually intense place, filled with the prayer offerings of the faithful and hopeful. Similarly, it might be said that the Quaker-raised Wes Christensen recognizes that a deserted Santa Monica beach fire ring can be imagined as a kind of postmodern funerary altar in *Pyre*.

Peter Adams, *Candlelight in St. Peregrine Chapel, Mission San Juan Capistrano,* 1999, oil on board, 18 x 24 in.

Wes Christensen, *Pyre*, 1992, watercolor and pencil, 4-3/4 x 9 in.

Patty Wickman, *Thief in the Night*, 1996, oil on canvas, 72 x 115 in.

Jacquelyn McBain, *St. Francis of Assisi*, 1994, oil on panel, 7-1/2 x 7-1/2 in.

Laura Lasworth, *The River*, 1997, oil on panel, 51 x 33 in.

Jacquelyn McBain, *Martyrdom of St. Sebastian*, 1994, oil on panel, 7-1/2 x 7-1/2 in.

Two artists who are Christian, Patty Wickman and Duncan Simcoe, have used their families and domestic settings to connect with the New Testament. In *Thief in the Night* Wickman drew on the Sermon on the Mount (Matthew 6:19–21) and one of St. Paul's letters (I Thessalonians 5:2) to paint a parable for our consumer culture. The monumental canvas depicts a burglar departing with some of the worldly goods of a young couple as they stand transfixed by their array of remaining possessions (the setting is the downtown Los Angeles studio of the artist and her husband and recalls an actual nocturnal break-in). On the other hand, Simcoe responded to the miraculous birth stories of Jesus in the Gospels of Matthew and Luke to reconfigure the Annunciation in his *Study for What if Kathi Was Mary?* a sketch for a series of paintings with the same title (Kathi and Duncan Simcoe are childless).

With a nod to the Baroque masters, the lives of the saints get an entirely novel interpretation in Jacquelyn McBain's series of small and claustrophobic oils. A self-described agnostic who is studious about religious matters, McBain reconfigured the saintly narratives by making them into hypersensually rendered flowers. In *Martyrdom of St. Sebastian*, an iris stands in for the martyr, pierced by agave thorns instead of arrows. McBain warmed to St. Francis when she learned that he spoke to animals and painted him as a hospitable peony, hosting in his petals a butterfly, a bird, two frogs, a wasp, and a beetle (*St. Francis of Assisi*). Reputed to consider all "belief systems" as equal, Mark Ryden turns his formidable painter's craft to the creation of fantasy scenes where spiritual and scientific notions are embodied and coexist in happy innocence, with no trace of contradiction (*Princess Sputnik*). His style runs in the vein of polished, sentimental calendar illustration as propelled by the imagination of a childish savant.

Brian Mains (see also *Body*) doesn't believe in a safe spirituality, at least as he draws and paints it. In Mains' darkly limned universe, light and dark, stasis and change, are the principal forces; it is a place where epiphanies sear consciousness before they do anything else (*Untitled*). Katie Phillips' explorations in her series *Spirit and Matter* (1990–98) portray the transcendent as existing to suffuse matter with light and energy. She represents this drama on an altar where, beneath a unitary radiance, the complex structure of a glowing sea lion's skull stands for the mystery of life and death.

If the Roman Catholic Church in the twenty-first century rediscovers a mission to proclaim the faith via an art that bespeaks the best of its past, as well as articulating a compelling form for the present, it will be through artists like Laura Lasworth. An adult convert, she created a diptych in the early 1990s that stylishly connected the philosophical legacy of St. Thomas Aquinas with the contemporary scholarship of Umberto Eco. More recently, she developed a series of paintings based on her reading of the letters, short stories, and novels of the twentieth-century American Catholic writer Flannery O'Connor. *The River*, based on O'Connor's short story of the same name, is Lasworth's evocation of the "baptismal death" of the story's protagonist, Ashfield. Superficially a still life, the painting is the artist's quiet memorial to a life purified in rebirth. The candy cane in the center of the vase between the branches of pomegranate and wheat shoots is in reality a monastic invention: traditionally hooked (for a catch), the swirling red and white bands represent the blood and purity of Christ.

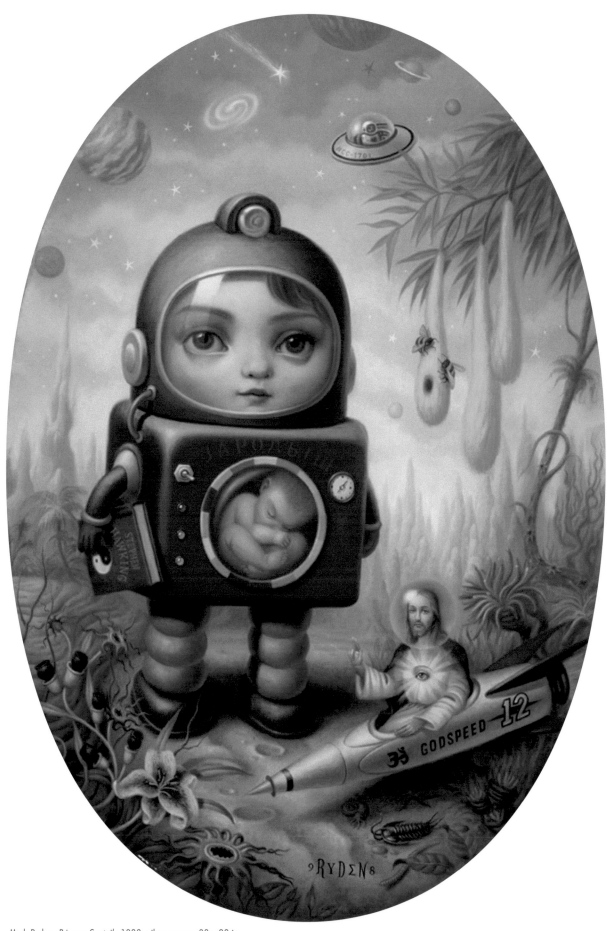

Mark Ryden, *Princess Sputnik*, 1998, oil on canvas, 32 x 22 in.

CHECKLIST

Height precedes width.
Dimensions are given in inches.

THE ARTIST

Cynthia Osborne *(b.1947)*, resides in Long Beach, *Megalith Envy*, 1998, lithograph and screenprint, 20 x 15. Courtesy of the artist *page 8*

F. Scott Hess *(b.1955)*, resides in Los Angeles, *Mud on a Stick*, 1999, oil on panel, 18 x 24. Courtesy of Michael Hackett, Hackett-Freedman Gallery, San Francisco *page 9*

Yu Ji *(b.1954)*, resides in Long Beach, *Street Corner*, 1994, oil on canvas, 40 x 30. Courtesy of the artist *page 10*

Ruth Weisberg *(b.1942)*, resides in Santa Monica, *Now, Then*, 1991, oil on canvas, 64 x 95-1/2. Courtesy of Jack Rutberg Fine Arts, Los Angeles *page 11*

Stephen Douglas *(b.1949)*, resides in Venice, *Untitled*, 1998, oil on linen, 108 x 55. Collection of Jeff and Mary Tucker *page 12*

Robert Williams *(b.1943)*, resides in North Hollywood, *The Were-Artist*, 1992, oil on canvas, 30 x 36. Collection of Greg and Kristin Escalante *page 13*

Enjeong Noh *(b.1969)*, resides in Pasadena, *Doppelgänger*, 1999, oil on canvas, 28 x 30. Collection of Mr. and Mrs. Walter Zifkin *page 13*

Jon Swihart *(b.1954)*, resides in Santa Monica, *Tenax Vitae*, 1997, oil on panel, 17 x 21. Collection of Maurice and Margery Katz

PORTRAITURE

Peter Zokosky *(b.1957)*, resides in Long Beach, *Habilis*, 1998, oil on panel, 10 x 8. Courtesy of the artist *page 15*

J. Michael Walker *(b.1952)*, resides in Los Angeles, *Retrato de Doncella Guadalupe (Portrait of Lady Guadalupe Covarrubias de Gutierrez)*, 1993, color pencil on paper, 50 x 38. Courtesy of the artist *page 16*

Margaret Morgan *(b.1958)*, resides in Los Angeles, *Portrait of Sigmund Freud as Feminine Sexuality*, 1993, pubic hair on linen, 8 x 8. Collection of Rebecca and Alexander Stewart *page 17*

Llyn Foulkes *(b.1934)*, resides in Los Angeles, *To Ub Iwerks (Portrait of Walt Disney)*, 1995, mixed media, 25-1/2 x 22-1/2. Courtesy of the artist and Patricia Faure Gallery, Santa Monica *page 18*

Richard Wyatt *(b.1955)*, resides in Los Angeles, *The Survivor*, 1990, oil on canvas, 72 x 72. Courtesy of Southern California Gas Company *page 19*

John Sonsini *(b.1950)*, resides in Los Angeles, *Gabriel*, 1998, oil on canvas, 30 x 24. Collection of Cliff Benjamin *page 20*

Salomon Huerta *(b. 1965)*, resides in Van Nuys, *Untitled Head*, 1997, oil on canvas, 12 x 11-1/4. Collection of Gianna Carotenuto *page 21*

Ira Korman *(b.1962)*, resides in Tarzana, *Jolyon (after Dürer)*, 1995, charcoal on paper, 30 x 19-1/2. Courtesy of Koplin Gallery, Los Angeles *page 14*

Sarah Perry *(b. 1956)*, resides in Acton, *The Miracle*, 1997, burnt tortilla on velvet, 14 x 13 x 2-1/4. Collection of Gloria and Sonny Kamm

Lance Richlin *(b. 1960)*, resides in Torrance, *Portrait of Tom Bierce*, 1996, oil on canvas, 24 x 20. Courtesy of the artist *page 21*

Craig Atteberry *(b. 1958)*, resides in Pasadena, *Chris*, 1999, oil on paper, 23-1/2 x 15-1/2. Courtesy of Lizardi Harp Gallery, Pasadena

IDENTITY AND SELF

Judith F. Baca *(b.1946)*, resides in Venice, *La Mestiza*, 1991, pastel on paper, 23 x 29. Courtesy of the artist *page 23*

Salomon Huerta *(b.1965)*, resides in Van Nuys, *Untitled Figure #1*, 1997, oil on panel, 67 x 32. Collection of Samuel and Shanit Schwartz *page 24*

Deni Ponty *(b.1952)*, resides in Los Angeles, *First Job*, 1999, oil on canvas, 40 x 30. Collection of Ed Evans, courtesy of Couturier Gallery, Los Angeles *page 25*

Dan McCleary *(b.1952)*, resides in Los Angeles, *Seven-Eleven, No. 2*, 1996, oil on canvas, 40 x 52. Collection of Taylor/DuRoss Trust *page 26*

Tom Knechtel *(b.1952)*, resides in Los Angeles, *The Old Centaur*, 1993, pastel on paper, 22-1/2 x 30-1/2. Courtesy of the artist *page 26*

D. J. Hall *(b.1951)*, resides in Venice, *Glee*, 1999, oil on linen, 14 x 42. Courtesy of Koplin Gallery, Los Angeles *page 27*

Robin Palanker *(b.1950)*, resides in Culver City, *Patience*, 1994, pastel on paper, 41 x 51. Collection of J. Foretenberry *page 28*

Sharon Allicoti *(b.1956)*, resides in Glendale, *Rear Window*, 1998, pastel on paper, 21 x 45. Courtesy of the artist *page 29*

Roberto Gil de Montes *(b. 1950)*, resides in Los Angeles, *Boy Indian*, 1998, oil on canvas, 10 x 8. Courtesy of Jan Baum Gallery, Los Angeles

Tony De Carlo *(b.1956)*, resides in Los Angeles, *His Everlast*, 1998, acrylic on canvas, 20 x 24. Collection of Frank and Trinie Valdez *page 22*

Cynthia Evans *(b. 1951)*, resides in Long Beach, *Something Blue*, 2000, oil on panel, 10 x 7-1/2. Courtesy of Koplin Gallery, Los Angeles *page 29*

THE BODY

Jim Morphesis *(b.1948)*, resides in Los Angeles, *Small Torso Painting in Yellow*, oil on gold-leafed panel, 17 x 12. Courtesy of the artist *page 31*

Kymber Holt *(b.1960)*, resides in Los Angeles, *Untitled (Ovaries)*, 1998, oil on panel, 6 x 27. Collection of Tom Peters *page 32*

Robert Graham *(b.1938)*, resides in Malibu, *Untitled - Series V*, 1992, cast copper bas-relief, 48 x 19 x 1-1/2. Courtesy of Remba Gallery, Los Angeles *page 32*

Alison Saar *(b.1956)*, resides in Los Angeles, *Terra Firma*, 1991, mixed media on wood, 18 x 74 x 22. Santa Barbara Museum of Art; purchased with funds provided by 20th Century Deaccessioning Fund and Friends of Contemporary Art *page 32*

Peter Zokosky *(b.1957)*, resides in Long Beach, *Untitled*, 2000, oil on panel, 31 x 22-1/2. Courtesy of the artist *page 33*

Peter Zokosky, *Untitled,* 2000, bronze, 20 x 8 x 5. Courtesy of the artist

David Limrite *(b.1958)*, resides in Glendale, *Drowned Anger*, 1998, mixed media on panel, 48 x 36. Courtesy of the artist *page 34*

John Frame *(b.1950)*, resides in Los Angeles and Wrightwood, *Poor Tom*, 1997, wood and found objects, 17 x 9 x 9. Collection of George and MaryLou Boone *page 35*

Tanja Rector *(b.1966)*, resides in Los Angeles, *Hands Series*, 1999, oil and wax on panel, 15 x 13 (each of three panels). Courtesy of the artist and Frumkin/Duval Gallery, Santa Monica *page 35*

Tanja Rector, resides in Los Angeles, *Untitled (Pregnant)*, 1999, oil and wax on panel, 72 x 40. Courtesy of the artist and Frumkin/Duval Gallery, Santa Monica

Leonard Seagal *(b.1958)*, resides in Los Angeles, *One Arm, Multicolored Love Beads*, 1998, cast ductile iron, glass love beads, 6 x 14 x 19-1/2 in. (lifesize with vertical bead string). Courtesy of the artist and POST, Los Angeles *page 35*

Sarah Perry *(b.1956)*, resides in Acton, *Darwin's Portal*, 1997, bones, granite, jute and copper, 11 x 7-1/2 x 7-1/2. Collection of Gloria and Sonny Kamm *page 30*

Brian Mains *(b.1950)*, resides in Monrovia, *Untitled*, 1996, acrylic on canvas, 66 x 48. Courtesy of the artist

Enrique Martinez Celaya *(b. 1964)*, resides in Venice, *The River*, 1997, oil, fabric, beeswax and plaster, 70 x 22 x 11. Courtesy of Griffin Contemporary, Venice

Enrique Martinez Celaya, *Spirit*, 1997, polyester resin with silk flower, 7 x 9 x 9. Collection of Heidi L. Schneider

NARRATIVE

Jim Shaw *(b.1952)*, resides in Los Angeles, *Study for a Horror Vacui*, 1991 (with Benjamin Weissman), pencil on paper, 21 x 38-1/4. The Museum of Contemporary Art, Los Angeles; purchased with funds provided by Sotheby's, Inc. *page 37*

Ruprecht von Kaufmann *(b.1974)*, resides in Los Angeles, *Requiem*, 1998, oil on canvas. 69 x 96. Courtesy of Lizardi Harp Gallery, Los Angeles *page 38*

Jorg Dubin *(b.1955)*, resides in Laguna Beach, *The Wait*, 1998, oil on canvas 35 x 41. Collection of Jeff and Mary Tucker *page 39*

Domenic Cretara *(b.1946)*, resides in Long Beach, *Caretaker*, 1999, oil on canvas, 66 x 84. Courtesy of the artist *page 39*

Aaron Smith *(b.1964)*, resides in Los Angeles, *The Little Glutton*, 1998, oil on panel, 36 x 27. Collection of Andrea Ruben, Courtesy of Ann Nathan Gallery, Chicago *page 40*

Anita Janosova *(b.1951)*, resides in Pasadena, *Coming of Age*, 1993, oil on linen. 94 x 72. Courtesy of Lizardi Harp Gallery, Los Angeles *page 36*

Sandow Birk *(b.1964)*, resides in Long Beach, *Northwards the Course of Immigration Makes Its Way*, 1999, oil and acrylic on canvas, 65 x 96. Collection of Stanley and Mikki Weithorn, courtesy of Koplin Gallery, Los Angeles *page 41*

Thomas Stubbs *(b. 1956)*, resides in Pomona, *Reconnaissance over Laguna Beach*, 1994, oil on panel, 24 x 20. Courtesy of the artist *page 42*

John Nava *(b. 1947)*, resides in Ojai, *2nd of May at Los Angeles*, 1992, oil on canvas, 78 x 120. Collection of Charles and Nancy Sims *page 43*

F. Scott Hess *(b.1955)*, resides in Los Angeles, *Renovation*, 1997, oil on linen, 48 x 64. Collection of Darrel and Marsha Anderson *page 44*

Christian Vincent *(b.1966)*, resides in Los Angeles, *Self-Projection*, 1997, oil on linen, 56 x 70. Collection of James and Vizma Sarnoff *page 45*

Richard Shelton *(b.1945)*, *Calling the Chosen*, 1997, oil on canvas, 48 x 84. Courtesy of the artist and Frumkin/Duval Gallery, Santa Monica *page 44*

Annette Bird *(b. 1925)*, resides in Pacific Palisades, *Emerging II*, 1997, bronze and wood (edition of six), 12-1/2 x 6-1/4. Courtesy of the artist and Jan Baum Gallery, Los Angeles *page 45*

Ann Chamberlin *(b. 1953)*, resides in Los Angeles, *Talk Show*, 1998, oil on board, 16 x 20. Courtesy of Patricia Correia Gallery, Santa Monica

Christopher Finch *(b. 1939)*, resides in Los Angeles, *Good Girl, Bad Girl, Tiki Room*, 1999, prismacolor and ink on paper, 22 x 30. Courtesy of Louis Stern Fine Arts, West Hollywood.

Gary Geraths *(b. 1955)*, resides in Claremont, Pages from sketchbook drawings depicting the electronic media, and drawn while covering the O.J. Simpson murder trial in downtown Los Angeles, 1995, colored pencil on paper, Numbers 1–3: 9 x 12; Numbers 4–8: 11 x 14. Courtesy of the artist.

Randall Lavender *(b. 1956)*, resides in Los Angeles, *Creation/Extinction*, 1992, oil on panel, 24 x 22. Collection of Jack Zuckerman; White, Zuckerman, Warsavsky, Luna and Wolf, CPAs, Sherman Oaks. *page 41*

CITY

Chaz Bojorquez *(b.1949)*, resides in Los Angeles, *El Desire, El Power, El Love in the U.S.A.*, 1995, mixed media on paper, 15 x 18. Private Collection *page 47*

Jonathan Burke *(b.1949)*, resides in Irvine, *Tie-Up*, oil on canvas, 36 x 48. Courtesy of the artist *page 47*

Peter Alexander *(b.1939)*, resides in Marina del Rey, *Saugus*, 1998, digitally enhanced painting (editioned), 42 x 46. Courtesy of the artist *page 48*

Lauren Richardson *(b.1951)*, resides in Los Angeles, *Eve's Garden*, 1991, oil on canvas, 84 x 60. Collection of Jeffrey Berg *page 46*

James W. Murray *(b.1944)*, resides in Manhattan Beach, *Untitled (Century Freeway Project)*, 1990, charcoal on paper, 6 x 8-1/2. Collection of Marie Murray *page 49*

Darlene Campbell *(b.1957)*, resides in Laguna Beach, *Orange County Wasn't Built in a Day*, 2000, oil on panel with gold leaf, 12 x 12. Courtesy of Koplin Gallery, Los Angeles *page 50*

Darlene Campbell, *Always Open*, 2000, oil on panel with gold leaf, 9 x 12. Courtesy of Koplin Gallery, Los Angeles

Stephanie Sanchez *(b.1948)*, resides in Los Angeles, *Across the Street, Palm Trees*, 1993, oil on panel, 8 x 14. Collection of Janine Smith *page 49*

James Doolin *(b.1932)*, resides in Los Angeles, *Psychic*, 1998, oil on canvas, 54 x 36. Private Collection *page 51*

Roberto Gil de Montes *(b. 1950)*, resides in Los Angeles, *Untitled*, 1999, oil on board, 5 x 7. Private Collection

LANDSCAPE

Gwynn Murrill *(b.1942)*, resides in Los Angeles, *Coyote VIII*, 1995, bronze, 30 x 47 x 10. Courtesy of L.A. Louver, Venice *page 53*

Barrie Mottishaw *(b.1945)*, resides in Los Angeles, *Mulholland and Coldwater*, 1997, oil on canvas. 11-1/4 x 17-1/4. Collection of Adam and Sherri Barr *page 53*

Darlene Campbell *(b.1957)*, resides in Laguna Beach, *Moving Mountains*, 1993, oil on wood with gold-leaf, 11 x 6-1/2. Collection of Robert and Ruth apRoberts *page 54*

Darlene Campbell, *A Simple Truth*, 1999, oil on wood with gold-leaf, 11 x 7. Collection of Mark Andrus, courtesy of Koplin Gallery, Los Angeles

John Register *(1939-96)*, resided in Malibu, *Motel by the Freeway*, 1995, oil on canvas, 50 x 70. Collection of Catherine Register *page 55*

David Hines *(b.1944)*, resides in Santa Clarita, *204th Street/Ave. H, Lancaster*, 2000, oil on canvas, 24 x 36. Collection of Peter and Rachel Strauss *page 55*

Bruce Everett *(b.1942)*, resides in Chatsworth, *Evening Haze*, 1998, oil on canvas, 48 x 72. Courtesy of the artist *page 56*

Phoebe Brunner *(b.1951)*, resides in Santa Barbara, *Walk on Top*, 1999, oil on canvas, 66 x 48.
Collection of Mark Andrus, courtesy of Koplin Gallery, Los Angeles *page 57*

Hilary Brace *(b.1956)*, resides in Santa Barbara, *Untitled*, 1996, pastel on paper, 18 x 32-1/2.
Collection of Evelyn Fortier *pages 52, 56*

Daniel Wheeler *(b.1961)*, resides in Los Angeles, *Hole*, 1997, mixed media, 11 x 22 x 16. Courtesy of the artist *page 57*

Rebecca Morales *(b. 1962)*, resides in Santa Ana, *The Salton Sea with Smoke Tree and Ocotillo*, 1999,
oil on aluminum panel, 10-1/2 x 30. Collection of Janine Smith

STILL LIFE

Jeffrey Gold *(b.1958)*, resides in Los Angeles, *Still-Life with Lemons*, 1996, oil on canvas, 27 x 21.
Collection of Tom and Darcy Klein *page 59*

Nick Boskovich *(b.1949)*, resides in Anaheim, *Heart of My Heart*, 1991, oil on panel, 5 x 7.
Collection of Paul Herndon *page 60*

Les Biller *(b.1934)*, resides in Los Angeles, *The Lion Sleeps in the Sun*, 1998, oil on linen, 48 x 60.
Courtesy of the artist and Louis Stern Fine Arts, West Hollywood *pages 58, 60*

Brad Coleman *(b.1961)*, resides in Laguna Beach, *Four Vegetables, Four Chardin Details*, 1998, oil on canvas,
24 x 24. Courtesy of the artist *page 61*

Emmanuel Cosentino *(b.1958)*, resides in Malibu, *Studio Still-Life 1*, 1993, oil on canvas, 24 x 30.
Courtesy of the artist *page 61*

Ruprecht von Kaufmann *(b.1974)*, resides in Los Angeles, *The Origin of Life*, 1998, oil on panel. 14 x 17.
Private Collection *page 62*

Ron Rizk *(b.1941)*, resides in Whittier, *A Site to Be Holed*, 1992, oil on panel, 17 x 36.
Courtesy of Koplin Gallery, Los Angeles *page 63*

Stephanie Sanchez *(b.1948)*, resides in Los Angeles, *Garbage Still-Life*, 1996, oil on panel, 24 x 32.
Collection of Jeanine and Josephine Moss

Enjeong Noh *(b. 1969)*, resides in Pasadena, *Still Life with Asian Pears*, 1999, oil on board, 7-3/4 x 7-3/4.
Collection of Sally Lamb

Diane Fraser *(b. 1954)*, resides in Los Angeles, *Peeled Orange*, 1999, oil on canvas, 16 x 20.
Courtesy of the artist and Frederick Baker Fine Art, Chicago

SPIRIT

Wes Christensen *(b. 1949)*, resides in Los Angeles, *Pyre*, 1992, watercolor and pencil, 4-3/4 x 9.
Collection of John and Lynn Pleshette *page 66*

Jacquelyn McBain *(b.1954)*, resides in Pasadena, *St. Francis of Assisi*, 1994, oil on panel, 7-1/2 x 7-1/2.
Collection of C. M. Brown *page 67*

Jacquelyn McBain, *Martyrdom of St. Sebastian,* 1994, oil on panel, 7-1/2 x 7-1/2. Collection of Jack Ledwith *page 68*

Kathryn Phillips *(b.1942)*, resides in Topanga, *Untitled* (from the *Spirit and Matter Series*), 1998, oil on panel,
36 x 30. Courtesy of the artist *page 64*

Laura Lasworth *(b.1954)*, resides in South Pasadena, *The River*, 1997, oil on panel, 51 x 33.
Collection of Mr and Mrs. John Morris *page 68*

Peter Adams *(b.1950)*, resides in Pasadena, *Candlelight in St. Peregrine Chapel, Mission San Juan Capistrano,*
1999, oil on board, 18 x 24. Courtesy of the artist *page 65*

Mark Ryden *(b. 1963)*, resides in Sierra Madre, *Princess Sputnik,* 1998, oil on canvas, 32 x 22.
Private Collection *page 69*

Duncan Simcoe *(b. 1956)*, resides in Riverside, *Study for What if Kathi Was Mary?* 1998, mixed-media drawing
on paper, 14 x 11. Collection of Jacques L. Garnier

Patty Wickman *(b. 1959)*, resides in Altadena, *Thief in the Night*, 1996, oil on canvas, 72 x 115.
Collection of Joe and Judy Sturman, courtesy of Shaheen Modern and Contemporary Art, Cleveland *page 66*

Brian Mains *(b. 1950)*, resides in Monrovia, *Untitled,* 1995, pastel and pencil on paper, 9 x 6.
Collection of Karen Carson and George Wanlass

ILLUSTRATIONS BY ARTIST